Lithography and Silkscreen

Fr

Lithography

Art an

chenberg

nd Silkscreen

Technique

Thames and Hudson

Editor: Theresa C. Brakeley

Designer: Ulrich Rüchti

The chapters in this book first appeared in
The Art of the Print by Fritz Eichenberg in 1976

This paperback edition first published in 1978

Printed and bound in Japan

Contents

Acknowledgments

The Art of the Print, from which this volume devoted to Lithography and Silkscreen was taken, was started in 1965 and slowly grew in size and scope, accompanied by the customary vicissitudes attending an author who is also a working artist, teacher, editor, and at times chairman, committee member, or organizer of this and that.

Without the help and advice of countless friends among artists, curators, and printers the book could never have been finished. My first thanks must go to Gail Malmgreen, who, as editorial assistant, bore the brunt of the labor of organizing and researching the material with unfailing intelligence and dependability. To Theresa C. Brakeley fell the task of checking the manuscript for accuracy, style, and structure, requiring experience and patience—qualities with which she is eminently endowed.

My gratitude is due also to the many curators and keepers of print collections here and abroad whose advice and active help in providing unusual and interesting illustrations were invaluable. I will start with Mr. Lessing J. Rosenwald and Curator Fred Cain at the Alverthorpe Gallery and Catherine Shephard and H. Diane Russell of the Rosenwald Collection, National Gallery of Art, Washington, D.C. Special thanks are also due to Kneeland McNulty, Curator of Prints, Philadelphia Museum of Art; to Dr. Heinrich Schwarz, former Director, Davidson Art Center, Wesleyan University; to Eleanor Sayre, Clifford Ackley, Sue Reed, and others on the staff of the Boston Museum of Fine Arts Print Collection; to Sinclair Hitchings, Keeper of Prints, Paul Swenson, and staff of the Boston Public Library; to Alan Fern, Curator of Prints, the Library of Congress; to Elizabeth Roth, Curator of Prints, the New York Public Library; to Riva Castleman and Donna Stein at The Museum of Modern Art in New York; to Alan Shestak, Curator, and his staff at the Yale University Art Gallery; to Ruth Magurn, Curator of Prints, the Fogg Art Museum, Harvard University; to Eleanor Garvey at the Houghton Library, Harvard University; to Janet Byrne of the Print Department of the Metropolitan Museum of Art, New York; to Joseph E. Young of the Los Angeles County Museum; to Elizabeth M. Harris, Curator of Prints, The Smithsonian Institution, and to Jacob Kainen, former Curator, Washington, D.C.; to Alice Mundt, Curator of Prints, Worcester Art Museum; to Gordon Washburn, Director of the Asia House Gallery, New York; and to the New Britain Museum of American Art, New Britain, Conn.

Among the members of foreign institutions I am indebted to Jean Adhémar, Cabinet des Estampes, Bibliothèque Nationale, Paris; Pål Hougen, Print Department of the Edvard Munch Museum in Oslo; Yura Roussakov and Larissa Douckelskaya of the Print Department of the Hermitage State Museum, Leningrad; the Staatliche Graphische Sammlung in Munich; the Albertina in Vienna; and the British Museum in London.

Among the galleries, Sylvan Cole and his staff at the Associated American Artists Gallery, New York, have been especially helpful; so have William H. Schab and the staff of his gallery in New York.

Some of the prints shown here have been created specifically to help make this book attractive and technically informative. Many of my artist friends have contributed color separations, work proofs, and special articles to enrich the technical sections. Knowing how difficult my requests often were to fulfill, I must be grateful for the time and effort expended on my behalf.

I am greatly indebted to my friend Erich Moench, formerly of the Academy of Fine Arts in Stuttgart, for his article and series of experimental prints reflecting his work in lithography; to Christian Kruck, Städel Art Institute, Frankfurt, for the description of his "stone painting" lithographs; to Maltby Sykes for his article on multimetal lithography; to Paul Wunderlich for contributing a rare print; to Reginald Neal for his notes on photolithography; to the late Federico Castellon, who described his work at Atelier Desjobert, Paris; and to Tadeusz Lapinski for creating a special series of proofs for this book.

Steve Poleskie and Robert Burkert develop their special silkscreen techniques in progressive proofs; James Lanier explains various photographic techniques in contemporary printmaking.

Gratitude is also due to E. Irving Blomstrann for his excellent photographs, his patience, and his advice, and to my hardworking colleagues in printshops, ateliers, and studios all over the world, who make the prints that make this book; to Mourlot, Lacourière-Frélaut, Desjobert, S. W. Hayter, and a host of others, perhaps less famous, all over Europe; to the workshops in our own country and the people who started them—Bob Blackburn, Tatyana Grosman, Irwin Hollander, Kenneth Tyler, June Wayne, and many others following in their footsteps.

Finally I must express my gratitude to Pratt Institute, which, in 1956, allowed me to start the Pratt Graphics Center (then the Pratt Contemporaries) in Manhattan, and which also supported my dream of publishing *Artist's Proof,* a periodical totally devoted to the contemporary print. Both ventures have given me an insight into the world of the print—its never-ending excitement and its bracing discipline—from which I have profited and which I hope I have been able to pass on.

CHAPTER 1
LITHOGRAPHY

History

PLATE 1

Lithography, along with the mezzotint, is one of the few graphic media which can be traced to its origin with comparative certainty. Like most inventors Alois Senefelder went through years of agony and deprivations, but with tenacity and by trial and error he perfected a technique of "chemical printing" which has not changed substantially to this day.

There were some forerunners who had etched on stone before. The Bavarian priest and teacher Simon Schmid had found a description of stone etching in an old Nuremberg textbook. He experimented with wax on stone, producing images of plants, maps, and anatomical subjects, which he etched with aqua fortis and actually printed by hand in 1787–88, some ten years before Senefelder began his first explorations on stone.

Nevertheless, we accord full honors to Senefelder, whose revolutionary chemical process made possible fast and economical printing of quickly produced images. He also constructed, undaunted by many failures and lack of money and recognition, a workable printing press capable of turning out editions of accurate reproductions at very low cost. Senefelder's long search for a printing process was not motivated by artistic curiosity. Born in Prague in 1771, the son of an actor, interested in the theater and in music, he wrote a play at the age of eighteen and soon became obsessed with the idea of establishing his own print shop, mainly for the purpose of reproducing his plays inexpensively.

Always short of funds, he first experimented with etching his texts on steel and impressing the letters on a layer of sand, clay, flour, and coal dust. When this impression had fully hardened, he filled the letters with a mixture of warm sealing wax and gypsum.

In this laborious way he produced a printable type and came close to inventing the process of stereotyping. Without money to perfect the process, he had to look for cheaper materials. He tried using copper and zinc plates "requisitioned" from his mother, made his own ink from wax, soap, and lampblack, succeeded in etching the design in relief, and pulled some impressions on a borrowed copper-plate press. Regrinding these plates, however, presented endless difficulties. Then fate brought him together with a piece of limestone from the nearby quarry of Solnhofen (Bavaria). At first he treated the stone with the same inks and etching materials he had used on copper and zinc, with little more success.

It was an accident which turned his efforts in an entirely new and fruitful direction. One day in 1798 he was sitting with a freshly prepared stone before him when his mother asked him to write down a laundry list. Not having paper and pencil handy, he quickly wrote the list on the stone with his own home-made ink, intending to copy it off later on. Before washing it off, he became curious to see the effect of acid on the inked stone. He etched it for five minutes with a mixture of aqua fortis and ten parts water. Making several false starts at inking the stone, he began to wash off the ink with soap and water. He discovered that the untouched parts of the stone, which had remained damp, rejected the ink because of the natural antipathy of water and grease. The letters, which retained traces of the greasy ink, repelled water and attracted additional ink from the roller.

The first lithographic print was born, and Senefelder was on his way to fame, if not to fortune. But countless difficulties seemed to block his way. He could not afford to buy stones, paper, and tools. He also needed the materials to produce a

workable press and somehow had to obtain commissions to finance and publicize his venture. Failing in all these attempts, he tried to sell himself as a substitute for a conscript in the Bavarian artillery. This ended in failure too, when, as an alien he was rejected by the local authorities.

By a lucky chance he got his first commission from Franz Gleissner, a court musician whose compositions Senefelder copied on stone and printed in 120 copies on a home-made etching press. The job was done in two weeks, at a profit of seventy guilders.

The word of a new inexpensive printing process spread rapidly, and commissions poured in. The old copper-plate press was scrapped and replaced by a new one of his own design. But endless trouble arose; the wooden cylinders split and inexperienced pressmen did the rest. Two years of misery and poverty followed, until a press of a different principle, using pressure moving laterally across the stone, was developed.

Since Senefelder was concerned mostly with the reproduction of text pages and musical scores, drawing on the stone in reverse became a problem. He sought a transfer method which would enable him to transmit images to the stone without reversing. He took an ordinary printed page, dipped it in a thin gum solution, then sponged it with a light mixture of oil and paint, which stuck to the printed letters but left the rest of the paper untouched. By laying a sheet of clean paper over it and pulling both through the press he was able to obtain a clean offset image in reverse. In fact, he was able to pull more than fifty prints from the same sheet without the benefit of a printing plate. This could have led to what we now call offset printing, or to printing from paper plates. But his restless mind led him back to the Solnhofen stone, in which he had discovered the quality of absorbing grease as freely when dry as it rejected it when wet.

He took a freshly polished stone, wrote on it with a piece of soap, poured on a thin solution of gum arabic, and wiped it with a sponge dipped in black oil paint. After dipping the sponge in water and rewiping several times, he found that the black adhered to the written lines but was easily wiped off the wet areas. By wetting the stone after each printing he could pull as many impressions as he desired, especially after replacing the sponge with a more efficient leather roller stuffed with horsehair. He also found that by etching the stone with a light acid solution he could raise the letters to a slight relief, which rendered inking and printing much easier.

He finally arrived at the following method: He washed the stone lightly with soap and water, dried it, drew the design on it with wax ink, etched it with aqua fortis, and poured on a gum solution to make the stone more receptive to grease and absorbent of water. This process has been passed on almost intact to the present generation of lithographic artists and printers.

Senefelder continued to experiment. He could reverse his process by pouring oil over the stone instead of water and using a watercolor ink. Then the oily areas would reject the color, while the wet areas absorbed it. By combining the two methods on one stone, using various inks and solutions, he could use relief, intaglio, and planographic methods simultaneously. (In principle this complex process is similarly used today in metal intaglio by S. W. Hayter.)

After years of hardship, supported by his faithful friends the Gleissners, and hardly taking time out to eat and sleep, Senefelder was finally able to document and

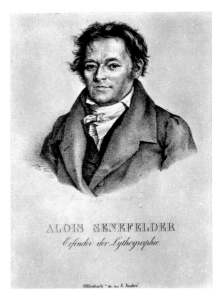

1 *Heinrich Ott.* Portrait of Alois Senefelder. *Early 19th century. Lithograph. Philadelphia Museum of Art*

deposit his invention in the British and Austrian patent offices. He also received a fifteen-year franchise from the Bavarian king, which at last gave him full protection in his own country.

Now the world became aware of Senefelder's work. The first bonanza was brought on by the visit of a wealthy music printer and publisher from Offenbach, Herr Johann André, who was much impressed by a demonstration which produced seventy-five printed sheets in a quarter of an hour—clean, fast, and economical. For the lordly sum of 2,000 guilders Senefelder was commissioned to set up a print shop in Offenbach and to train craftsmen in all manipulations of the process.

Next he succeeded in transferring a print from an etched copper plate to the stone and was able to get thousands of sharp impressions from this transfer method (later used again in France by Rodolphe Bresdin, Odilon Redon's teacher).

He established the fact that "chemical printing," as he called it, could be used on wood, metal, *and* paper. If the inks were treated properly, they could even be made to reject other inks through the addition of acids or alkaline solutions. Even wax, shellac, or rosin could be made to resist oil-based inks.

This again led the inventor to further experiments, which produced "stone paper," a substitute less costly and less fragile than stone. After trying various mixtures, he worked out a composition of clay, chalk, linseed oil, and metallic oxides which formed a stonelike coating on paper, linen, wood, metal, and other surfaces and proved more resistant than the actual litho stone. Years later the artist Géricault heard of this "stone paper" formula while on a visit to London and produced several successful pen lithographs in the medium.

A request for color printing made Senefelder think of a stencil method. Rollers, to which were attached felt, cloth, or leather pieces in the shape of the color areas, were inked and rolled over the stone. The shades of color could even be varied with the textures of the applicators. To the color roller was attached another one serving as an ink font. The font in turn was fed from a little feeder box containing ink and mounted atop the second roller, in much the same system, in miniature, as is used today on our big automatic printing presses.

The following ten years read like the Lamentations of Jeremiah, as Senefelder relates them in his *Lehrbuch,* published in 1818—a little too late for his own good. It is the story of a kindhearted and dedicated man, gullible and trusting, constantly betrayed by family and friends, utterly incapable of conducting business affairs, and at the mercy of countless imitators and greedy investors who were eager to exploit his invention for their own ends.

His odyssey took him first to London, then to Vienna, where he became involved in schemes of stone printing for the cotton industry, in squabbles with dealers and publishers over the reproduction of art work, and in unsuccessful attempts to establish lucrative music "printeries."

He continued, however, to pursue his experiments. He studied intensively the chemistry of color, perfected lithographic inks and acids, tried aquatint and crayon processes, printed color from several plates, and developed a process of etching directly into the stone and copper cylinders used in textile printing presses.

Meanwhile lithography gained in popularity and spread across Europe, without paying substantial dividends to its inventor. In 1809 Gottlob Heinrich von Rapp, a gifted Bavarian amateur, published *Das Geheimnis des Steindrucks . . . (The Secret of*

Lithography . . . , Tübingen), giving away the secrets of the invention to anyone for the price of the book.

Soon print shops were established all over Europe, in London, Paris, Vienna, Prague, Madrid, Barcelona, St. Petersburg, and Moscow. They also appeared in Senefelder's own backyard, in German states beyond Bavarian jurisdiction.

In 1809 a modest and belated recognition came to Senefelder when he was appointed director of the Royal Tax Commission's print shop in Munich "by his most gracious King Maximilian Joseph." This enabled him to dedicate himself again wholeheartedly to improvements in his invention. He sums up his achievements and aspirations at the end of Section I of the famous *Lehrbuch*.

The Lithograph as an Art Medium

PLATES 2-3

François Johannot, a cousin of Johann André, the Offenbach printer, is credited with having been the first to encourage artists in the use of the new medium for purely artistic purposes. Among those whose prints he published as early as 1801 in his

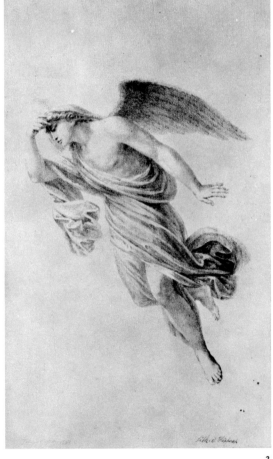

3

2 *Karl Schinkel.* Lovely Melancholy. *1810.*
Pen lithograph. Philadelphia Museum
of Art

3 *Joseph Hafner.* Angel. *1823. Lithograph,*
10 3/4 × 8 1/4". Collection the author

2

Offenbach print shop was Wilhelm Reuter (1768–1834), a Prussian court painter of some talent. In 1804 Reuter published a portfolio of pen and crayon lithographs by "outstanding Berlin artists," including Schadow, Mitterer, Genelli, and others.

In England several well-known artists contributed to a series entitled *Specimens of Polyautography* published by Philipp André in 1803. Only two groups of six prints each appeared, although six groups were originally planned. The artists who contributed included the American expatriate Benjamin West, the Swiss Heinrich Füssli, and some thirty others, with "original drawings made on stone purposely for this work."

PLATE 4

In France it was apparently Napoleon himself who early recognized the importance of the new medium. He probably acted on the advice of his new Director General of the Paris museums, Dominique Vivant Denon, himself not a bad artist and lithographer. Frédéric André, twenty-two-year-old brother of Johann, received a patent from the French government in 1802 for this *"nouvelle méthode de graver et imprimer."*

PLATE 5

Now lithography was established as a fine arts medium, to reach its peak in France with the work of Toulouse-Lautrec nearly a century later. It seems amazing that these early and rather competent experiments in lithography were made more than fifteen years before the publication of Senefelder's textbook. Napoleon's officers frequently "invaded" German print shops and returned home with materials and technical details of the new invention, acting as "industrial spies."

In 1816 Godefroy Engelmann and Charles de Lasteyrie opened a lithographic print shop in Paris which attracted a number of prominent French artists, among them Carle and Horace Vernet, Baron Gros, Pierre Guérin, teacher of Géricault, and Auguste Raffet. Their reputations became established in the afterglow of the Napoleonic era, with prints full of heroic exploits romanticizing the *Grande armée* and its campaigns.

PLATES 8, 12

Achille Devéria (1800–1857), who created more than three hundred lithographs,

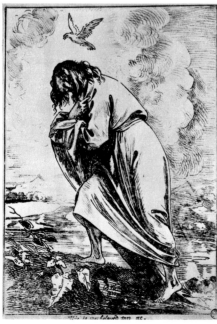

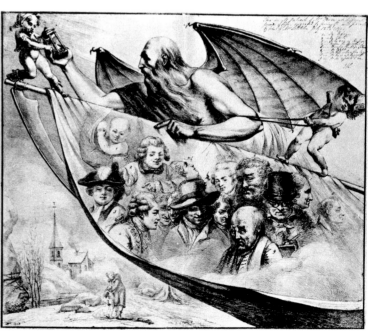

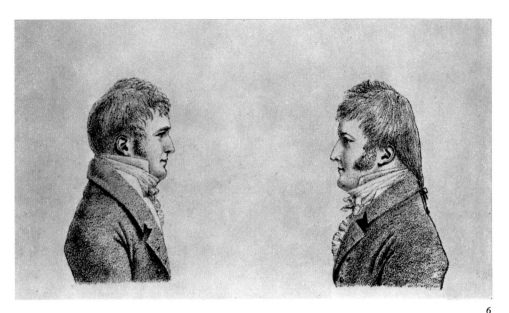

4 *Benjamin West.* This Is My Beloved Son. *1802. Pen lithograph, 12 5/8 × 8 3/4″. Library of Congress, Washington, D.C.*

5 *Dominique-Vivant Denon.* Allegory of Time *(with self-portraits). 1818. Lithograph. Museum of Fine Arts, Boston*

6 *Antoine-Philippe d'Orléans, Duc de Montpensier.* Portrait of the Artist and His Brother. *1805. Lithograph. Museum of Fine Arts, Boston*

7 *Nicolas-Toussaint Charlet (1792–1845).* "Je suis innocent!" dit le conscrit. *Lithograph, 22 × 28″. Museum of Fine Arts, Boston*

6

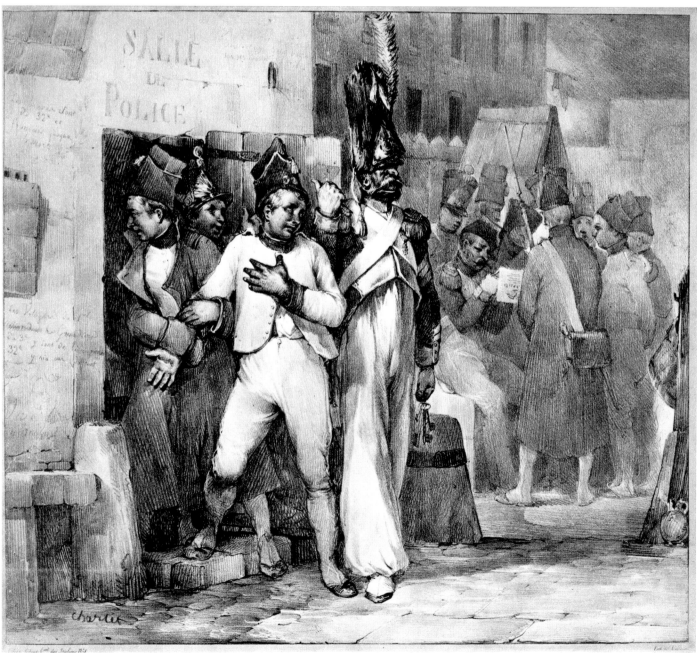

7

8 *Horace Vernet.* Portrait of Carle Vernet. *1818. Lithograph. Museum of Fine Arts, Boston*

9 *Achille Devéria.* Victor Hugo. *1828. Lithograph, 6 3/4 × 5 1/4". Bibliothèque Nationale, Paris*

10 *L. Berger.* Intérieur d'une Chambre Militaire. *Early 19th century. Lithograph. Philadelphia Museum of Art (Ars Medica Collection)*

11 *Anonymous French.* Vue de l'Imprimerie Lemercier, 7 rue de Seine, Paris. *c. 1845. Lithotint. Philadelphia Museum of Art*

12 *Auguste Raffet.* Self-portrait. *1848. Lithograph. Museum of Fine Arts, Boston*

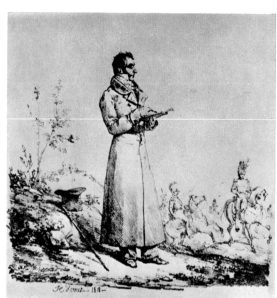

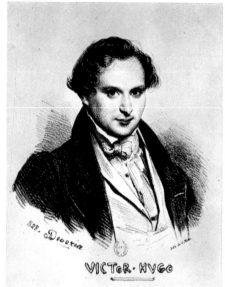

8

9

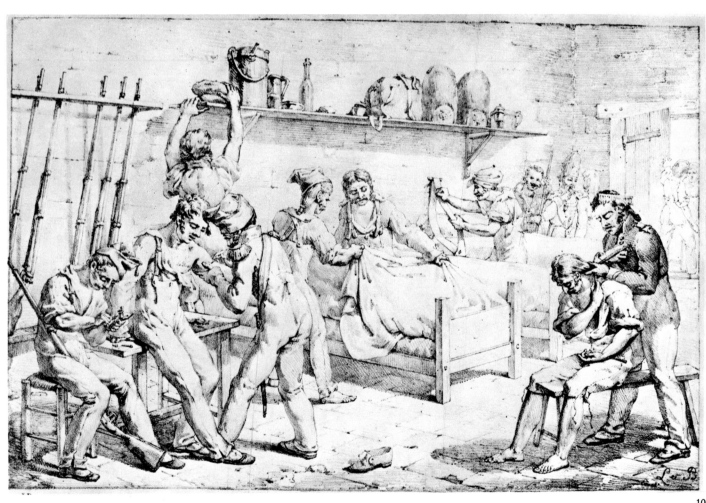

10

later became Conservateur of the Cabinet des Estampes of the Bibliothèque Nationale, an appointment which shows the esteem artist-lithographers had attained. He portrayed many of his friends, Mérimée, A. Dumas, Walter Scott, Géricault, David, Constant, and others, and helped make the lithographic portrait popular.

PLATE 9

Lithography was dabbled in by noblemen and their ladies and promoted by kings and emperors. Louis Bonaparte, brother of Napoleon, drew the "Four Men of the Imperial Guard" on stone in a Munich workshop in 1805. Louis-Francois Lejeune, adjutant general to Marshal Berthier, and a painter in his own right, has left us a number of competent lithographs.

The European Masters

Géricault (1791–1824), at the urging of his friend Charlet, traveled to London in 1820 for the exhibition of his painting *The Raft of the Medusa,* which was creating a sensation. The prints of his English sojourn were concerned mainly with the London scene, from prize fights in Soho to the lower depths of the slums (*Great English Suite* —twelve lithographs). But, of course, Géricault achieved his greatest fame with battle scenes, full of spirited horses and gallant warriors, drawn in an accomplished crayon technique.

PLATE 14

In a similar vein Eugène Delacroix (1798–1863) began to try his hand in the new medium with the lithographed studies of the Elgin marbles, done in 1825. The seventeen lithographs for Goethe's *Faust,* published only three years later, received the highest praise from the author himself. "Delacroix," he said, "has surpassed my

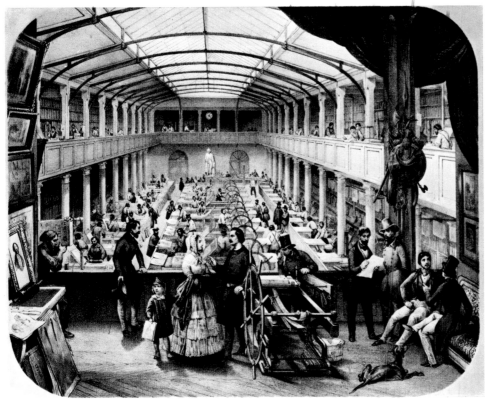

11

12

own imagination in scenes which I created myself; how much more will they come to life for the average reader and exceed *his* imagination." Although rejected by the French public, these lithographs in their technical perfection are considered a milestone in book illustration. In later years Delacroix illustrated many other important books with lithographs, among them *Hamlet* and works of Scott and Byron, but these prints never quite reached the dramatic impact of the *Faust*.

In 1819 José Maria Cardano founded the first lithographic workshop in Ma-

PLATE 16

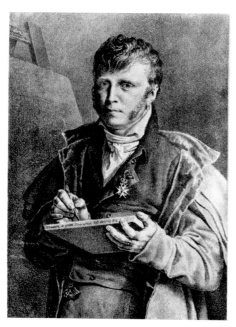

13

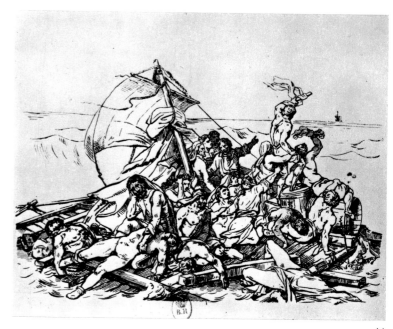

14

13 *Joseph Odevaere.* Portrait of the Artist Drawing on Stone. *1816. Lithograph. Fogg Art Museum, Harvard University, Cambridge, Mass.*

14 *C. Hullmandel (after Théodore Géricault).* Shipwreck of the Medusa. *1820. Pen lithograph, for the catalogue of the London exhibition. Bibliothèque Nationale, Paris*

15 *Eugène Isabey (1804–86; attrib.).* Mont St. Michel. *Lithograph. Museum of Fine Arts, Boston*

16 *Eugène Delacroix.* Weislingen Attacked by Goetz's Followers. *1834. Lithograph. National Gallery of Art, Washington, D.C. (Rosenwald Collection)*

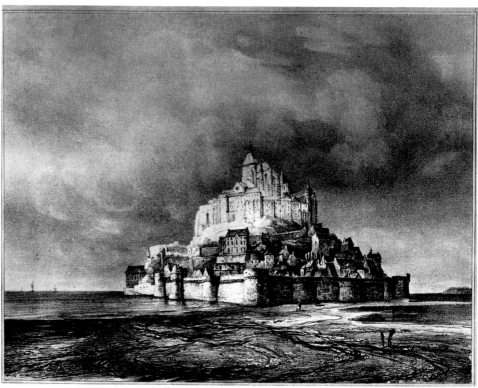

15

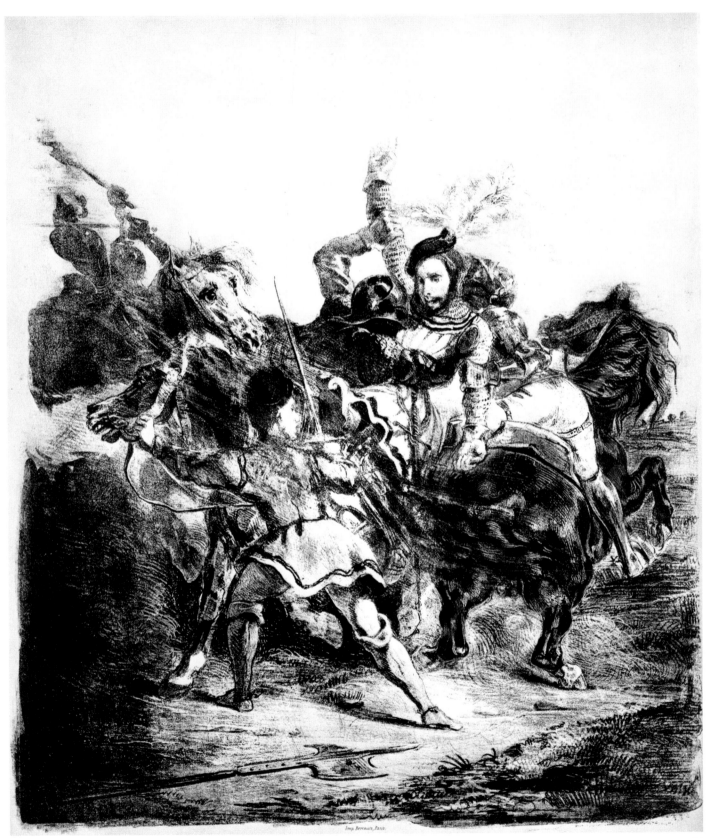

Imp. Berteaux, Paris.

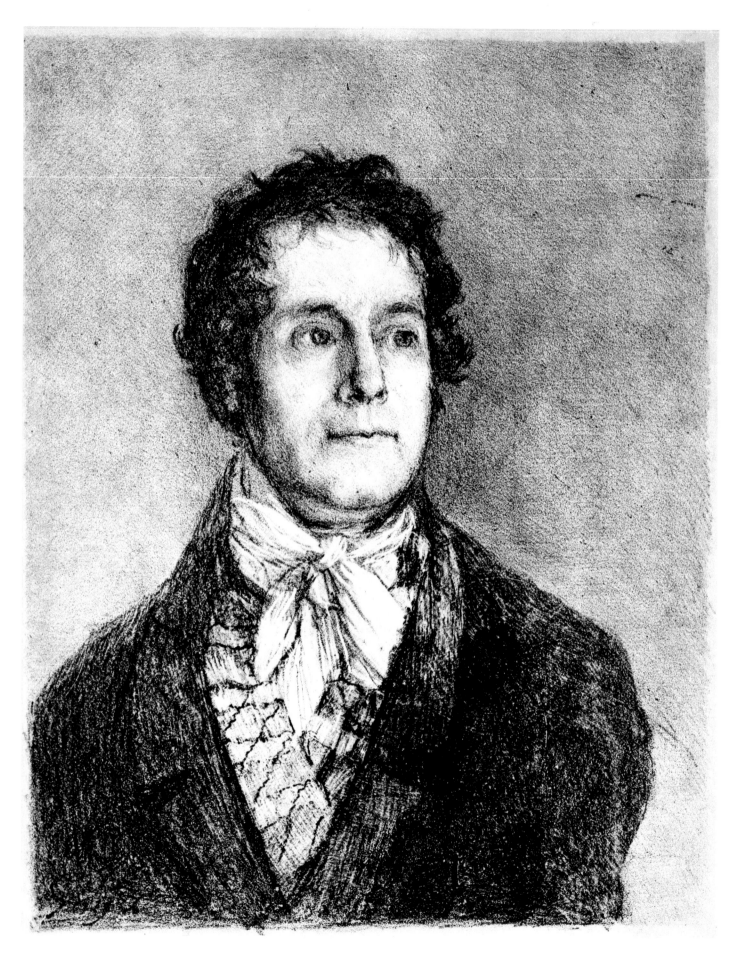

17 *Francisco de Goya*. Portrait of Cyprien–Charles–Marie–Nicolas Gaulon. *1825. Lithograph, 10 5/8 ×
8 1/4". Davidson Art Center, Wesleyan University, Middletown, Conn.*

drid, followed by another one in Barcelona, through which Goya became familiar with the new technique. Senefelder's textbook had just been translated into English and French when Goya's first lithographs appeared, among them *The Monk, The Duel,* and *The Descent to Hell,* in very small editions and now extremely rare. His experiments were forcibly cut short by his exile to France in 1822. There, three years before his death, he created the four great lithographs *The Bulls of Bordeaux,* a high point of artistic and technical achievement in the history of graphics.

In 1808, in Marseilles, Honoré Daumier, another giant of the lithograph, was born. No other artist has achieved such fluency on the stone; no other has devoted himself so wholeheartedly to the lithograph as a vehicle for his concern with the burning issues of the day. An avalanche of four thousand lithographs issued from his workshop onto the pages of *Le Charivari* and *La Caricature,* and from there into thousands of homes all over France. The influence of this keen observer of public life was tremendous, and reaction in the high circles which he attacked was instantaneous. Daumier truly belongs to our age of protest, and many of his lithographs

PLATES 17, 18

PLATES 19-23, 25

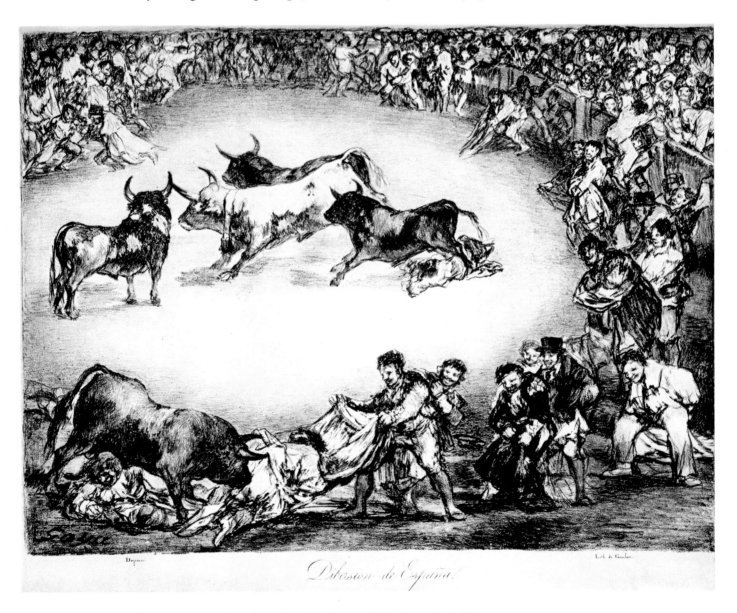

18 *Francisco de Goya.* Spanish Entertainment, *from* The Bulls of Bordeaux. *1825. Lithograph, 11 3/4 × 16 1/8". National Gallery of Art, Washington, D.C. (Rosenwald Collection)*

19 *Honoré Daumier.* A Literary Discussion
in the Second Balcony. *1864.*
Lithograph, 7 3/4 × 7 1/8". Collection
the author

20 *Honoré Daumier.* Souvenir de
Sainte-Pélagie *(with self-portrait). 1834.*
Lithograph. Museum of Fine Arts,
Boston

21 *Honoré Daumier.* Scène de Tribunal
(Court Scene, or The Verdict). *c. 1830.*
Drawing, 13 13/16 × 16 1/2". National
Gallery of Art, Washington, D.C.
(Rosenwald Collection)

22 *Honoré Daumier.* Lafayette Done For.
1834. Lithograph. National Gallery of
Art, Washington, D.C. (Rosenwald
Collection)

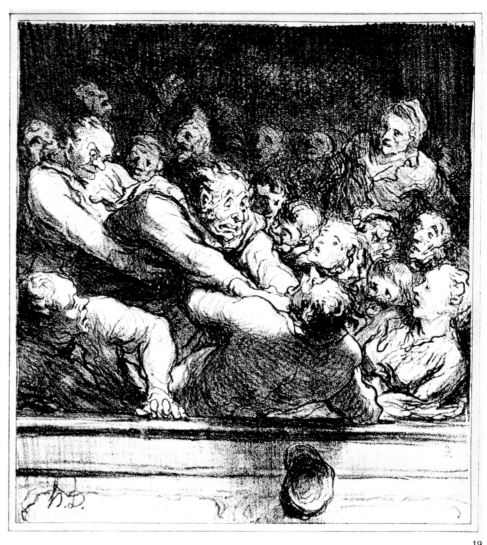

19

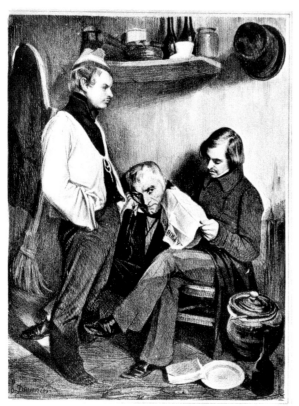

21

poignantly reflected France's social and political unrest, from the last days of Napoleon to the end of the Franco-Prussian War.

Charles Philipon, left-wing editor of the weekly *La Caricature* and the daily *Le Charivari*, shared the spotlight with Daumier, who worked closely with him from 1832 to 1872, with brief interruptions caused partly by Daumier's urge to paint and partly by a prison term for *lèse-majesté*. It was Philipon who was allegedly responsible for many of the biting captions which accompanied Daumier's prints. In a forty-year period the artist produced an average of one hundred lithographs a year, not to speak of countless drawings, paintings, and pieces of sculpture, until cataracts blurred his penetrating eyes in 1872. Death followed seven years later. His body was saved from a pauper's grave by the efforts of his old friend Corot.

COLORPLATE 1

Around Daumier worked a group of talented young artists, though perhaps none as daring and incisive as the master in the use of the print as a political weapon. There was the elegant Gavarni, worshiping feminine beauty; the prolific Grandville, camouflaging human frailties in animal skins and costumes; there was Monnier, lambasting the bourgeoisie and the politicians; and Pigal, Cham, and Traviès,

PLATES 26-28

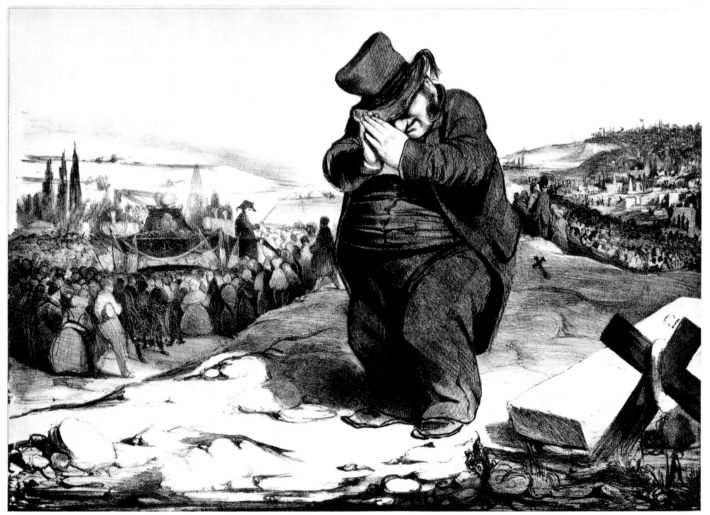

23 *Honoré Daumier.* "Pardon Me, Sir, If I Disturb You a Little," *from* The Bluestockings. *1844. Lithograph. National Gallery of Art, Washington, D.C. (Rosenwald Collection)*

24 *Louis Dupré.* Louis-Philippe, Duc d'Orléans. *1830. Lithograph, 10 1/2 × 9". Collection the author*

25 *Anonymous (after Honoré Daumier).* La Poire. *1831–33. Wood engraving, 7 3/8 × 6 7/8". Collection the author*

26 *Paul Gavarni.* Avoir la Colique—le Jour de Ses Noces. *1838. Colored lithograph. Philadelphia Museum of Art (Ars Medica Collection)*

27 *Paul Gavarni (1804–66). Print from* Études d'Enfants. *Lithograph. Courtesy William H. Schab Gallery, New York*

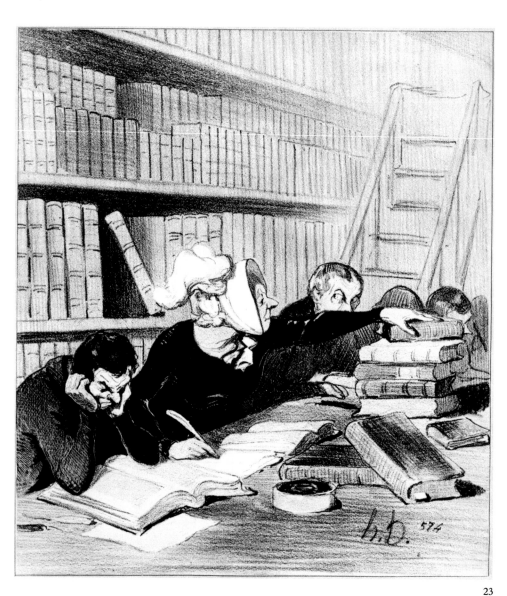

23

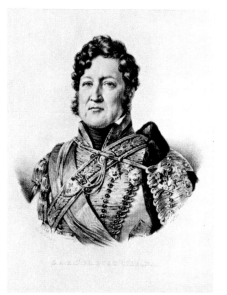

24

25

producing a flood of pointed lithographs that inundated the country and strongly influenced political opinion.

It also occurred at the very beginning of Daumier's career that two other lithographers, Daguerre and Nièpce, made their first breakthrough into another chemical printing process, photography, through the use of lenses and by sensitizing glass or paper with silver nitrates. Nadar, Bayard, Talbot, and D. O. Hill share with them the honor of creating a process of reproducing documentary images inexpensively. Without their invention today's news media and instant mass communication could not function.

Photography, however, did not sidetrack many artists. Some became increasingly attracted by the hitherto unexplored possibilities of the lithographic stone, the textures of its surface, and its chemical reactions.

Manet, strongly influenced by Goya, created memorable prints of passion and violence, among them lithographs for E. A. Poe's "The Raven" and *La Barricade,* *PLATES 29, 30* from *Scène de la commune de Paris.* To Degas the lithograph provided another medium to celebrate the female body. Odilon Redon, trained by Bresdin, who used pen on *PLATES 33, 34* stone so masterfully, constantly explored new ways of reaching the deepest, richest blacks. Like no one else of his time he conjured out of the stone a "surrealist" dream world, full of mysterious symbolism.

In Fantin-Latour, Félicien Rops, Willette, Steinlen, Forain, and Maurice Denis, *PLATES 32, 35-37*

26

27

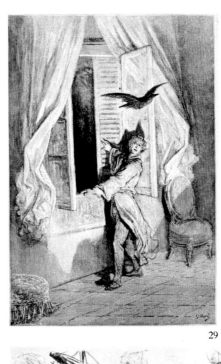

29

30

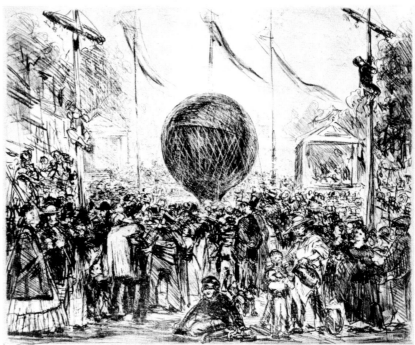

31

28

28 Paul Gavarni. Bal Masqué. Lithograph. National Gallery of Art, Washington, D.C. (Rosenwald Collection)

29 Anonymous (after Gustave Doré). Illustration for E. A. Poe, "The Raven." 1884. Wood engraving, 8 7/8 × 13". New York Public Library, Astor, Lenox and Tilden Foundations (Prints Division)

30 Édouard Manet (1832–83). Illustration for E. A. Poe, "The Raven." 1875. Lithograph. New York Public Library, Astor, Lenox and Tilden Foundations (Prints Division)

31 Édouard Manet. The Balloon. Lithograph. Fogg Museum of Art, Harvard University, Cambridge, Mass.

32 Henri Fantin-Latour.
À la Mémoire de
Robert Schumann.
1873. Lithograph
(scraping technique).
Museum of Fine Arts,
Boston

Imp. Lemercier & Cⁱᵉ Paris

a la mémoire de Robert Schumann
17 · 18 · 19 Aout 1873

. Fantin .

34

33 *Rodolphe Bresdin*. Branchage. *c. 1856. Lithograph, 4 1/8 × 2 3/4".*
Bibliothèque Nationale, Paris

34 *Odilon Redon*. "Je vis dessus le contour vaporeux d'une forme humaine," *from*
La Maison Hantée. *1896. Lithograph, c. 9 × 6 1/8". Courtesy William
H. Schab Gallery, New York*

35 *Félicien Rops (1833–98)*. Le Quatrième Verre du Cognac. *Lithograph.*
Collection Walter Bareiss, New York

36 *Maurice Denis*. Ce Fut un Religieux Mystère. *1898. Color lithograph.*
Brooklyn Museum, New York

33

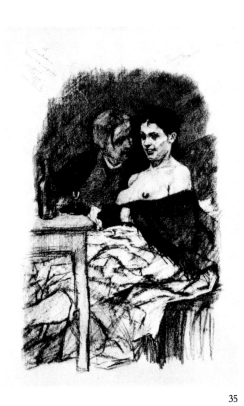

35

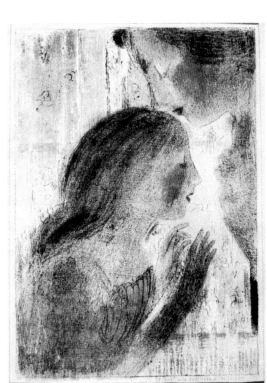

36

competent artists and lithographers all, one can detect the beginning of a decadence in both technique and subject matter. They concerned themselves with sex, politics, and social injustice without ever reaching the grandeur of a Daumier.

As the turn of the century neared, Henri de Toulouse-Lautrec (1864–1901), a Bohemian aristocrat, crippled early in life, appeared on the scene in a burst of brilliance, wit, and vitality. He combined in his person many diverse and fascinating talents. His passion for the performing arts, his compassion for the dancers and singers and their satellites, the streetwalkers of Montmartre, whom he befriended, opened a beguiling world fashion. He created a new art form in its service—the poster, for *COLORPLATE 2* which he found the most appropriate medium in the color lithograph, raising that medium to new heights. There is no difference of artistic quality between his paintings and his graphic works. His first color lithograph, *La Goulue at the Moulin Rouge,* *PLATES 38-40* appeared in 1891. There followed a series of inspired posters and prints in a medium he never abandoned until illness laid him low in 1895. Even at the sanatorium in Neuilly, one year before his death, he created one of his finest series—thirty-nine crayon drawings on the theme of the circus *(L'Âme du Cirque),* which, alas, he could never put on a litho stone. Three hundred seventy lithographs, countless drawings, book illustrations, pastels, and paintings give testimony to an intense and compassionate life, burned out in thirty-six years.

Ancourt's print shop, where Toulouse-Lautrec had worked for many years, was the ideal meeting ground for artists, craftsmen, and publishers, working together in *COLORPLATE 3* harmony. During these same years Pierre Bonnard (1867–1947) reached the peak of perfection in his treatment of the color lithograph, with a gay and lyrical touch, undoubtedly influenced by the first invasion of Japanese prints. He, like his friend

37 Jean-Louis Forain (1852–1931). The Private Salon. Lithograph. National Gallery of Art, Washington, D.C. (Rosenwald Collection)

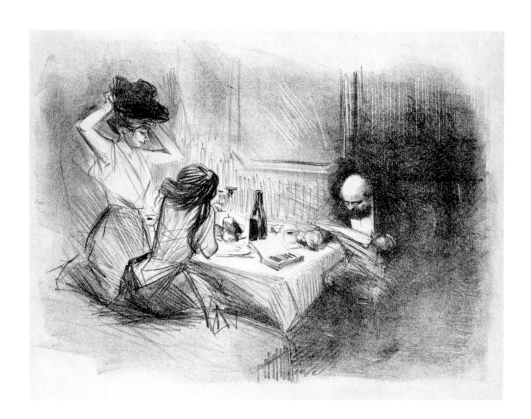

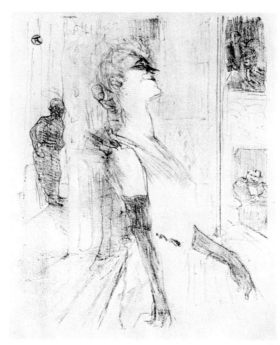

38

39

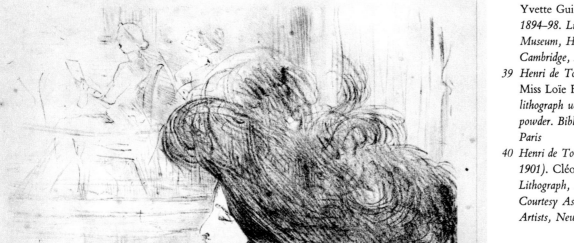

38 *Henri de Toulouse-Lautrec.*
 Yvette Guilbert (Sur la Scène).
 1894–98. Lithograph. Fogg Art
 Museum, Harvard University,
 Cambridge, Mass.

39 *Henri de Toulouse-Lautrec.*
 Miss Loïe Fuller. 1892. Color
 lithograph with watercolor and gold
 powder. Bibliothèque Nationale,
 Paris

40 *Henri de Toulouse-Lautrec (1864–*
 1901). Cléo de Merode.
 Lithograph, 11 1/2 × 8 3/8".
 Courtesy Associated American
 Artists, New York

40

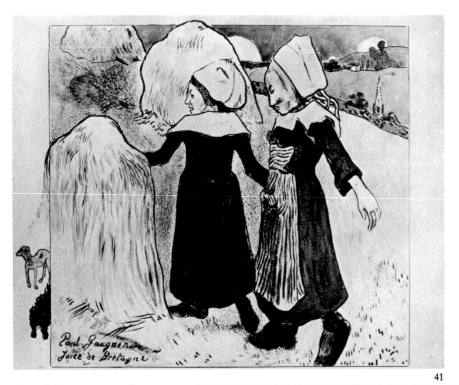

41

41 Paul Gauguin. Joys of
Brittany. *c. 1888. Lithograph.
Museum of Fine Arts, Boston*
42 Edgar Degas. Après le Bain.
*c. 1890. Lithograph, 9 1/8 ×
9 1/16". Museum of Fine
Arts, Boston*
43 Vincent van Gogh. The
Potato Eaters. *1885.
Lithograph, 8 1/2 × 12 3/8".
Museum of Modern Art,
New York (gift of Mr. and
Mrs. A. A. Rosen)*

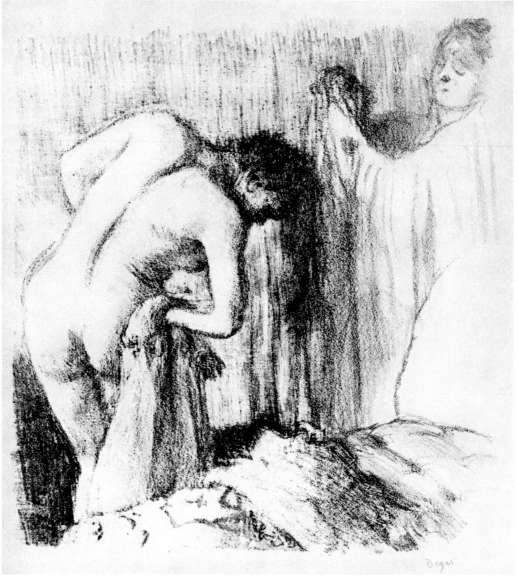

Edouard Vuillard (1868–1940), was interested in the poster, the book, and the little incidental graphics which grew out of an intimacy with a congenial medium.

COLORPLATE 4

It seems quite evident that the knowledge and experience of the painter dealing with color and light is essential to the success of the printmaker. How much more exciting are the prints of the great painters who became interested in graphics as an extension and not as a reproduction of their paintings! Cézanne's, Gauguin's, and Renoir's few lithographs bear witness to that—especially if we contrast them with the work of Steinlen, Forain, and others, journalists of the stone.

PLATES 41-46
COLORPLATE 5

In Norway Edvard Munch created a vast body of prints, mostly inspired by his paintings. He experimented with woodcut, etching, and lithography, but it seems that it was the last which appealed to him most. He got his start in Paris at Auguste Clot's workshop, where he met Bonnard and Vuillard; but his moody, Nordic style is distinctly his own.

PLATES 47, 49

Among the lesser lights of the nineteenth century who worked on stone were Eugène Carrière in France and Adolf von Menzel in Germany, who experimented with a kind of mezzotint-lithograph, *à la manière noire*. The stone was covered with tusche and the high lights scraped and scratched out of the dark surface.

PLATES 48, 50

Though the Russian tradition in graphics has always favored the woodcut and

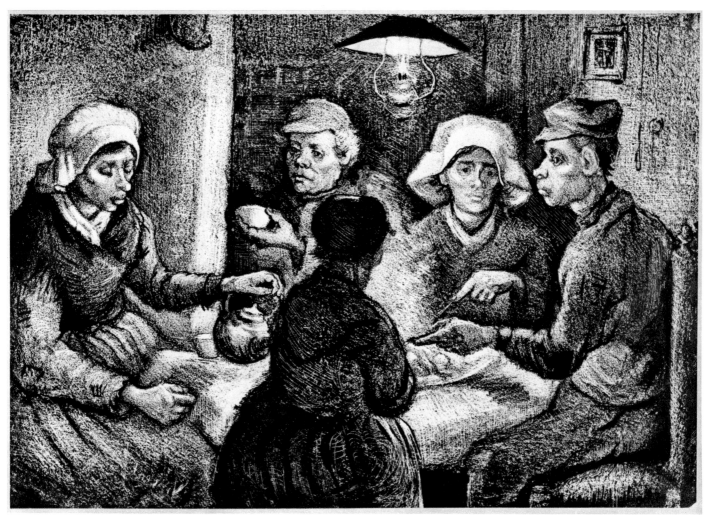

44 *Auguste Renoir.* Portrait of Cézanne. *1902. Lithograph, c. 6 1/8 × 4 7/8″. Courtesy William H. Schab Gallery, New York*

45 *Camille Pissarro.* Paul Cézanne. *1874. Etching. Philadelphia Museum of Art (Louis E. Stern Collection)*

46 *Paul Cézanne.* Self-portrait. *c. 1890–94. Lithograph. Fogg Art Museum, Harvard University, Cambridge, Mass.*

47 *Edvard Munch.* Title page of La Critique. *1896. Lithograph. Brooklyn Museum, New York*

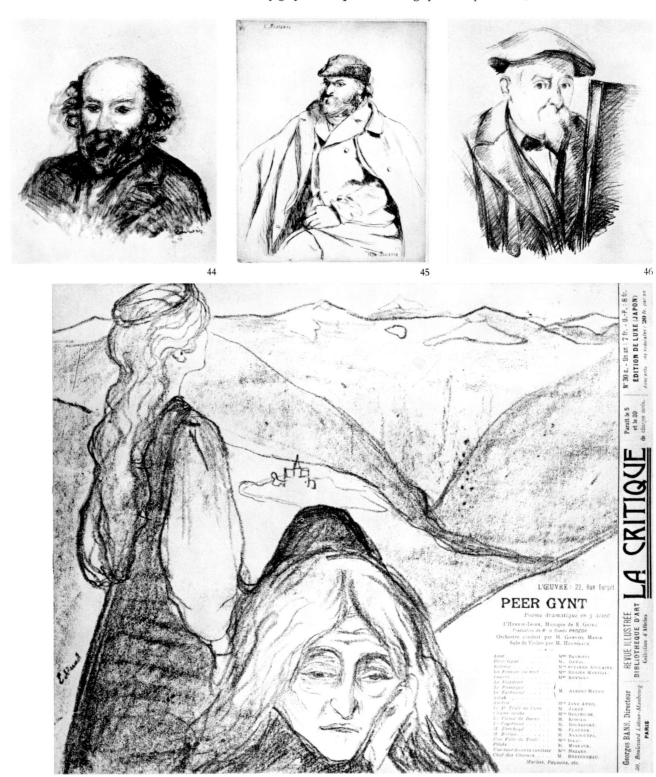

44 45 46

47

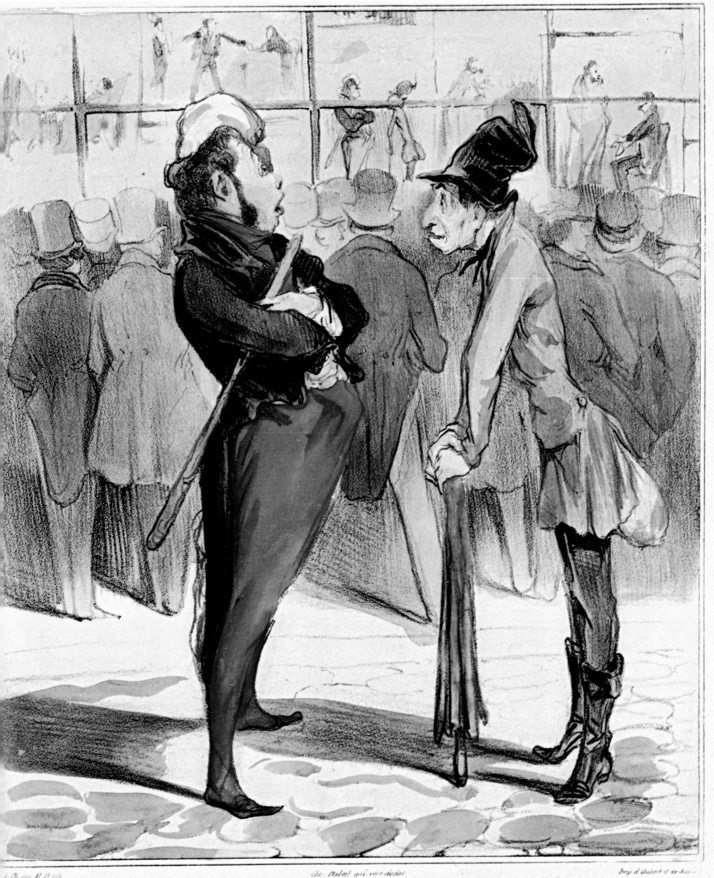

1 *Honoré Daumier.* Robert Macaire and Bertrand. *c. 1834. Colored lithograph.* Museum of Fine Arts, Boston

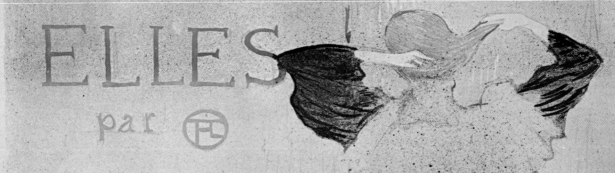

ELLES
par

Lithographies
éditées par
G. Pellet
9, Quai Voltaire à Paris
Exposées à la PLUME
31, Rue Bonaparte, à partir du
22 Avril 1896

2 *Henri de Toulouse-Lautrec. Poster for the portfolio*
Elles, *published by G. Pellet, Paris, 1896.*
Color lithograph, 20 3/8 × 15 3/4". Museum
of Modern Art, New York (gift of Abby
Aldrich Rockefeller)
3 *Pierre Bonnard.* Portrait en Famille. *1893–94.*
Color lithograph, 8 1/2 × 10 1/2". Courtesy
Associated American Artists, New York

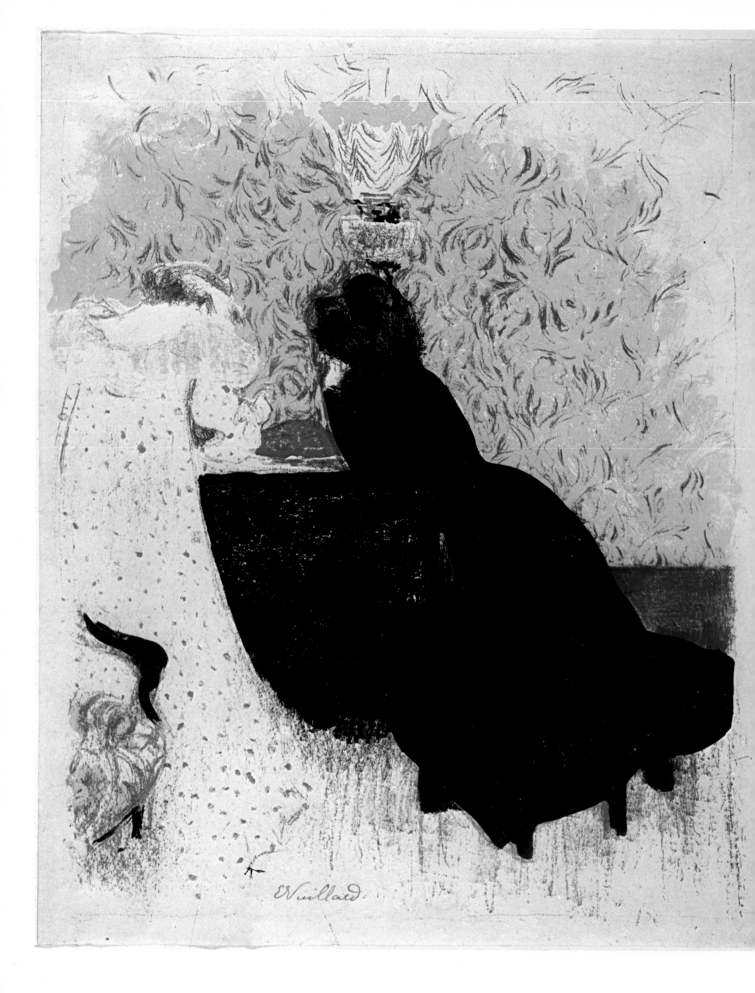

4 *Édouard Vuillard (1868–1940)*. Les Deux
 Belles Soeurs. *Color lithograph, 13 3/4 × 11 1/8″.*
 Courtesy William H. Schab Gallery, New York
5 *Paul Cézanne*. The Bathers *(small plate)*. 1897.
 Color lithograph, 9 1/8 × 11 3/8″. Courtesy
 Associated American Artists, New York

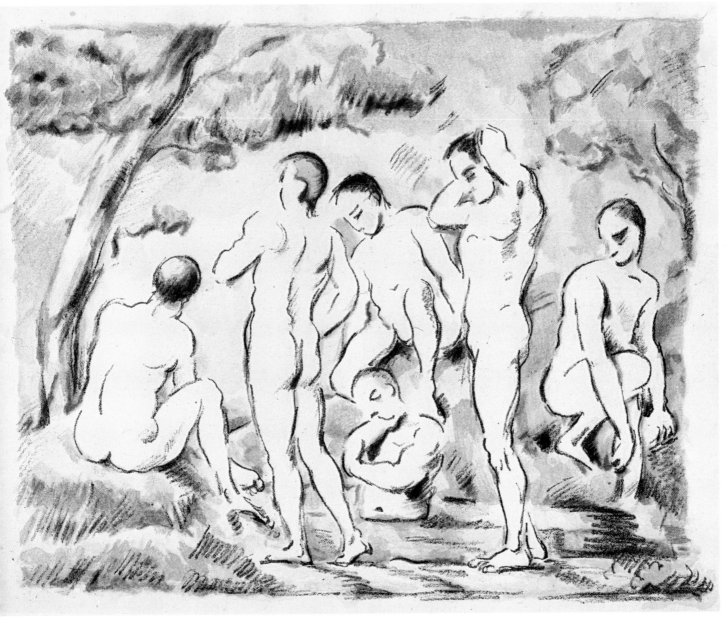

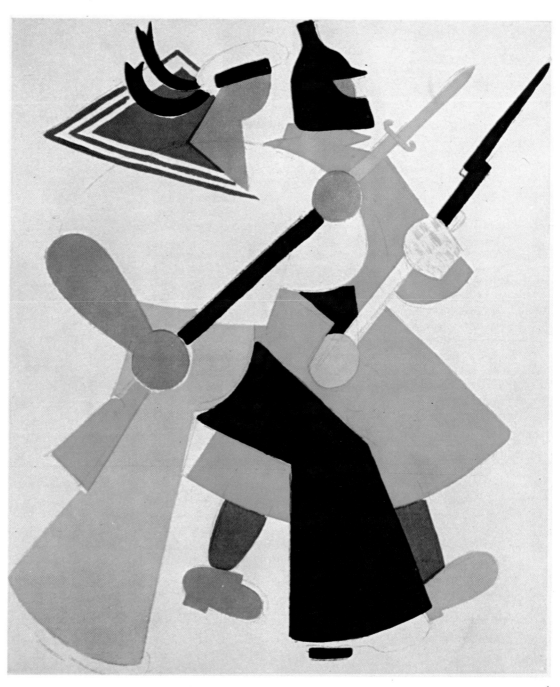

6

6 *Ivan Lebedev*. Red Army Soldier and Sailor. *1922.*
Color lithograph, c. 8 1/8 × 7″. (From Werner
Schmidt, Russische Graphik des XIX und XX
Jahrhunderts, *Leipzig, 1967)*
7 *Fernand Léger*. Marie, the Acrobat. *1948. Color*
lithograph, 21 11/16 × 16 13/16″. Museum of Modern
Art, New York (gift of Victor S. Riesenfeld)

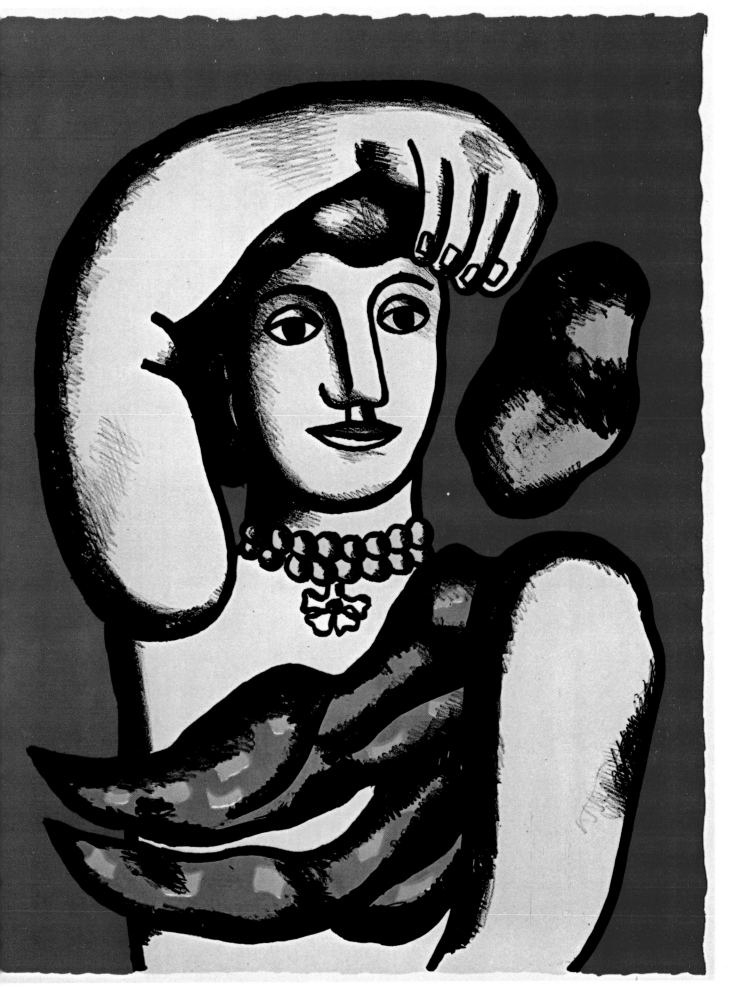

8 Georges Braque. Chariot III. 1955. Embossed color lithograph, 12 5/8 × 16 5/8″. Museum of Modern Art, New York (gift in honor of René d'Harnoncourt)

wood engraving, lithography must be considered a strong second. Largely inspired by the lithographs of Daumier and Gavarni, a group of creditable satirists, led by P. M. Boklevski and A. I. Lebedev, portrayed the turbulent Russia of the 1860s in historically interesting prints.

The post-revolutionary generation followed rather closely this narrative vein, as may be seen in the competent lithographs of B. M. Kustodijev and A. N. Samochvalov. The best work, perhaps, was produced in children's books by Tsharushin and V. Lebedev in the 1920s. The Experimental Graphic Workshop, set up in Leningrad under A. L. Kaplan, was chiefly responsible for a revival of interest in lithography. The work was competent but actually far from experimental.

Far more exciting for Western taste were the earlier graphics of the Constructivists, a bold, inspired group whose movement started shortly before the Revolution and, unfortunately, ended shortly after it, being too intellectual and iconoclastic for the party bosses. Their work has lost none of its sparkle and inventiveness. Finest among those working experimentally on the stone were Archipenko, Jawlenski, Larionov, and Gontcharova, but the truly pioneering works were Kandinsky's *Kleine Welten* and El Lissitzky's portfolio *Victory over the Sun* (1923).

Perhaps the commercialization of lithography as a means of producing cheap

COLORPLATE 6

48 Adolph von Menzel. Brush and Scraper. *1851. Lithograph. Staatliche Graphische Sammlung, Munich*

49 Edvard Munch. Bear and Omega. *1909. Lithograph, 10 × 8 1/2". Courtesy Associated American Artists, New York*

50 Eugène Carrière. Sleep. *1897. Lithograph (scraping technique). Philadelphia Museum of Art*

PLATES 51, 52

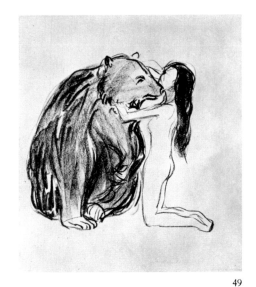

49

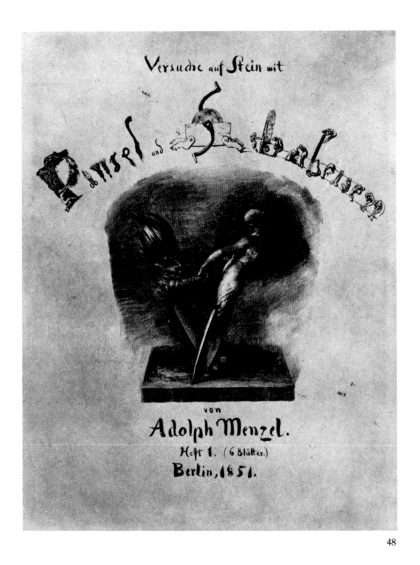

48

50

posters, wine and cigar labels, barroom decorations, postcards, and calendars, mostly done in chromolithography, caused its decline as a creative medium. It was to be brought to life again with the birth of German Expressionism and with Ambroise Vollard, an inspiring example for enterprising publishers and artists everywhere. He initiated in Paris his superb and daring publishing venture, which, in thirty years, encompassed all the important artists of his time. With them he created great books and portfolios of an artistic and technical quality never reached before and hardly ever achieved thereafter.

In Germany such publishers as Kurt Wolff and Bruno Cassirer gave impetus to a new interest in prints as a medium for artists. Beginning with Max Liebermann at the turn of the century, the lithographic stone became a source of inspiration to such artists as Lovis Corinth, Max Beckmann, Ernst Barlach, Käthe Kollwitz, and Oskar

PLATES 53-56

51 *El Lissitzky*. Foam Machinery, *Plate 1 from* Electro–Mechanical Spectacle. *1923. Color lithograph. Brooklyn Museum, New York*

52 *Alexander Archipenko*. Two Nudes. *1921. Lithograph, 19 3/4 × 13 3/8". Courtesy Mrs. Frances Archipenko, New York*

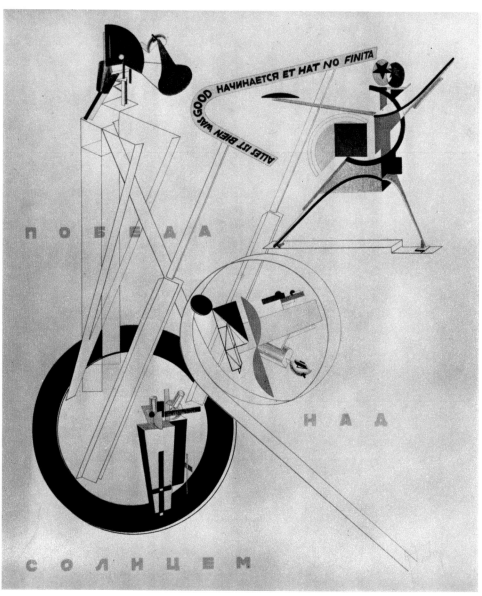

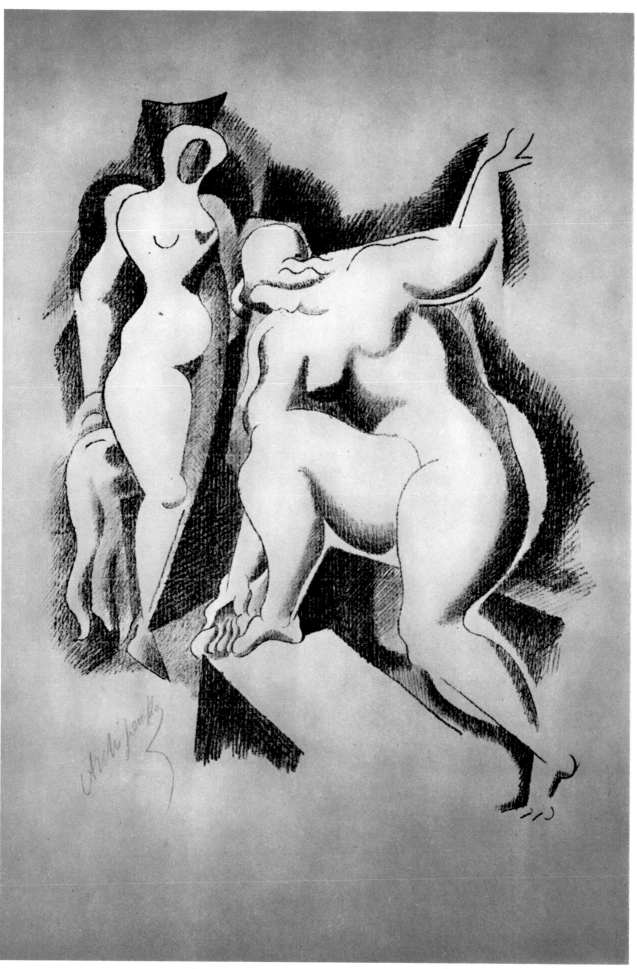

52

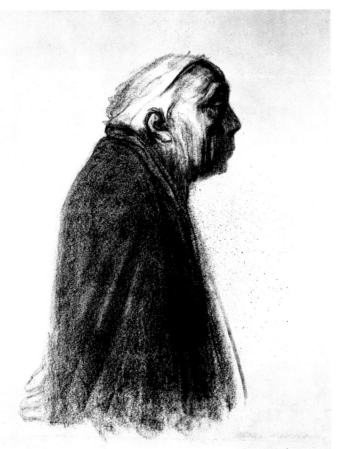

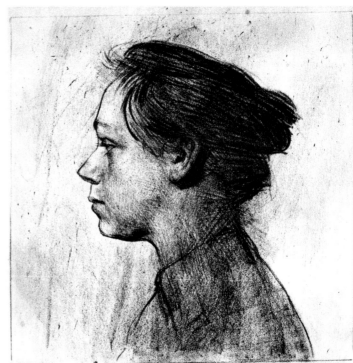

54

53

53 *Käthe Kollwitz. Self-portrait. 1938. Lithograph, 18 3/4 ×
11 1/4". National Gallery of Art, Washington, D.C.
(Rosenwald Collection)*

54 *Käthe Kollwitz. Self-portrait—Left Profile. 1898. Lithograph,
5 7/8 × 5 7/8". Museum of Fine Arts, Boston*

55 *Käthe Kollwitz. Self-portrait. 1924. Woodcut, 5 7/8 ×
4 3/8". National Gallery of Art, Washington, D.C.
(Rosenwald Collection)*

56 *Käthe Kollwitz. Self-portrait. 1934. Lithograph. Museum of
Fine Arts, Boston (Helen and Alice Colburn Fund)*

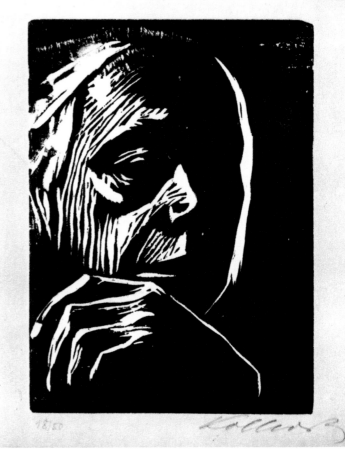

55

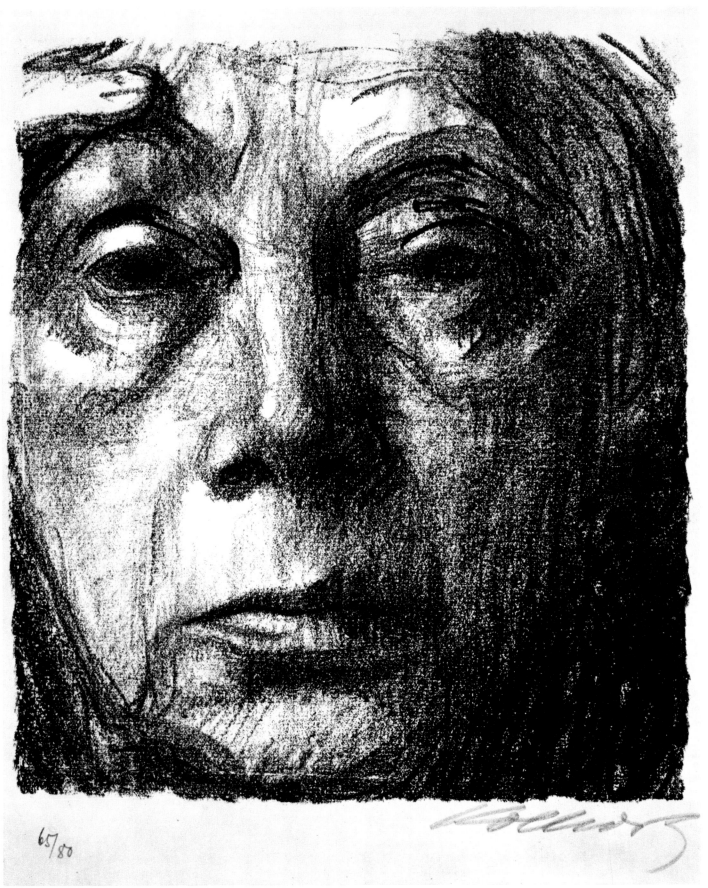

65/80

57

58

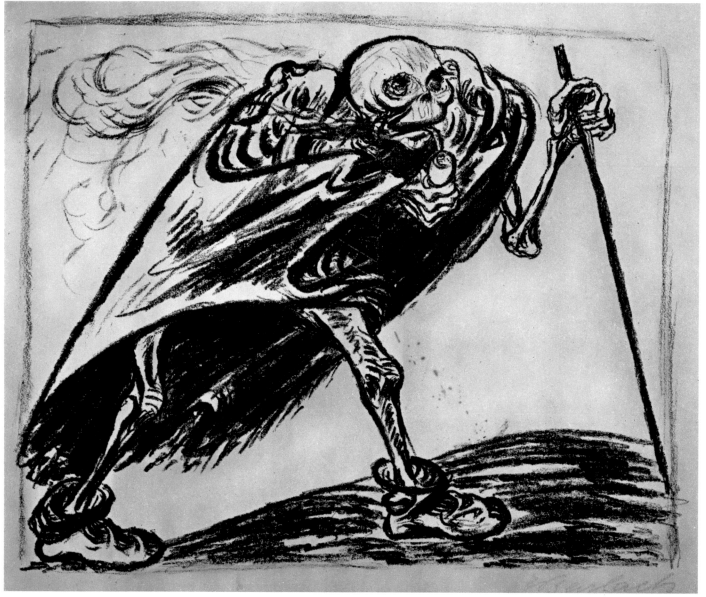

59

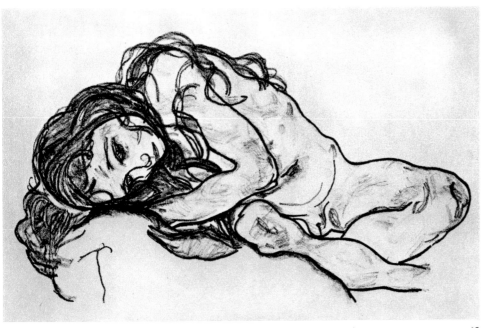

60

61

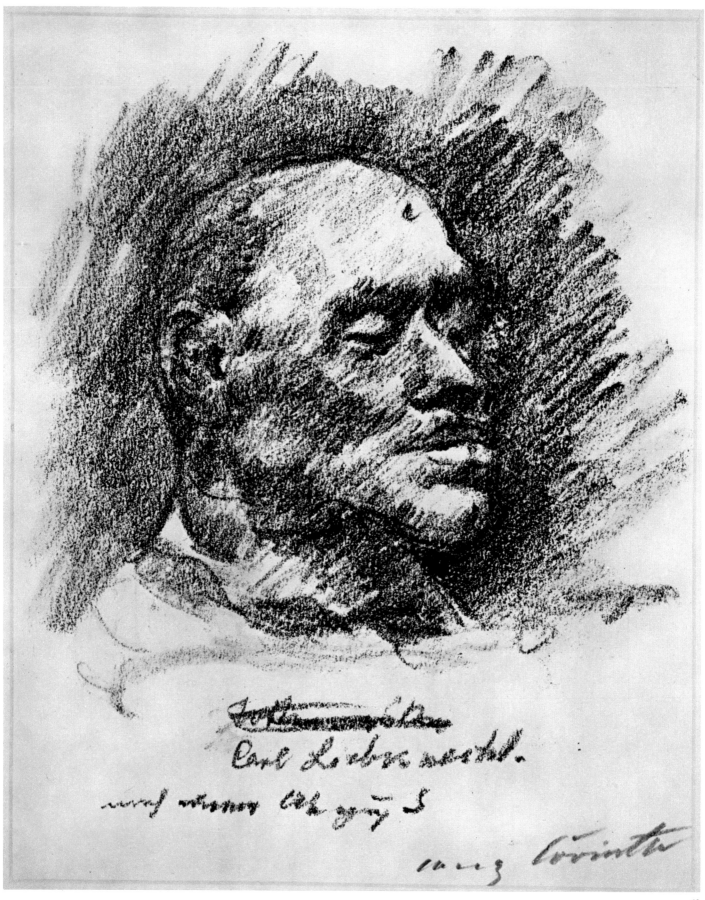

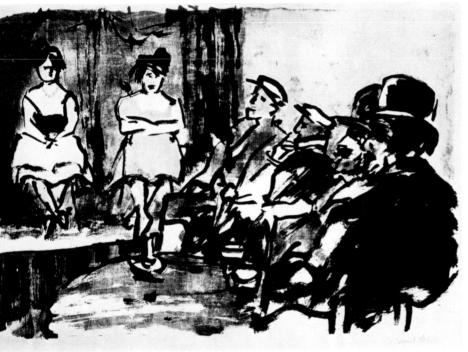

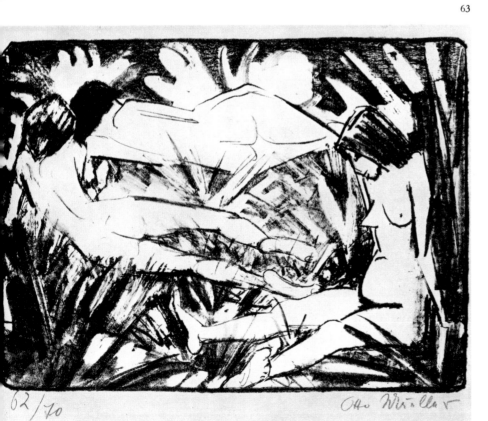

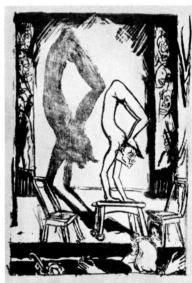

62 *Lovis Corinth.* Karl Liebknecht *(from a death mask). c. 1919. Lithograph. National Gallery of Art, Washington, D.C. (Rosenwald Collection)*

63 *Emil Nolde.* Tingel-Tangel III. *1907. Color lithograph, 12 3/4 × 19 1/16". Philadelphia Museum of Art*

64 *Otto Müller (1874–1930).* Three Nudes, Two Lying in the Grass. *Lithograph. Philadelphia Museum of Art*

65 *Erich Heckel.* Acrobat. *1916. Lithograph, 11 × 8". Courtesy Associated American Artists, New York*

63

65

64

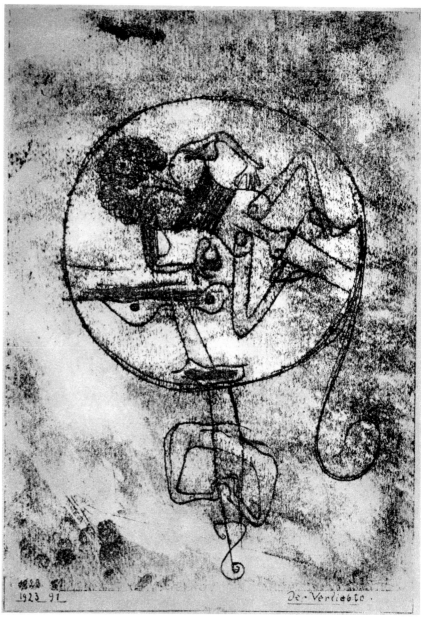

67

66

66 *Kurt Schwitters (1887–1948)*. Abstraction. *Lithograph. Philadelphia Museum of Art*
67 *Paul Klee*. A Man in Love. *1923. Color lithograph. Philadelphia Museum of Art (Carl Zigrosser Collection)*
68 *Josef Albers*. Self-portrait. *c. 1918. Lithograph, 18 1/8 × 12 3/4". Library of Congress, Washington, D.C.*
69 *George Grosz*. Self-portrait for Charlie Chaplin. *1919. Lithograph, 19 1/2 × 13 1/8". Philadelphia Museum of Art (Carl Zigrosser Collection)*
70 *George Grosz*. Storm Clouds, Cape Cod. *1949. Lithograph, 8 3/4 × 13". Courtesy Associated American Artists, New York*

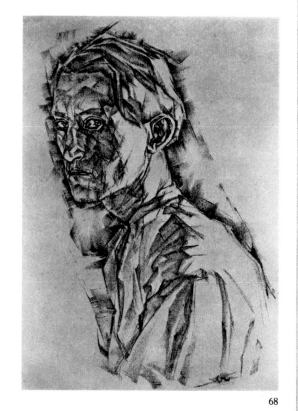

68

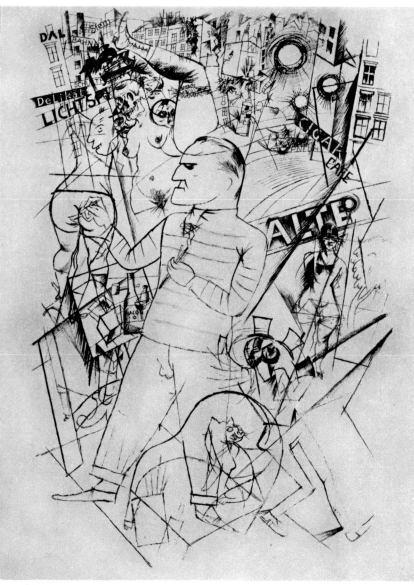

69

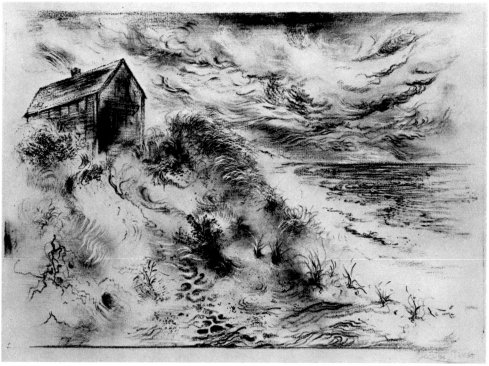

70

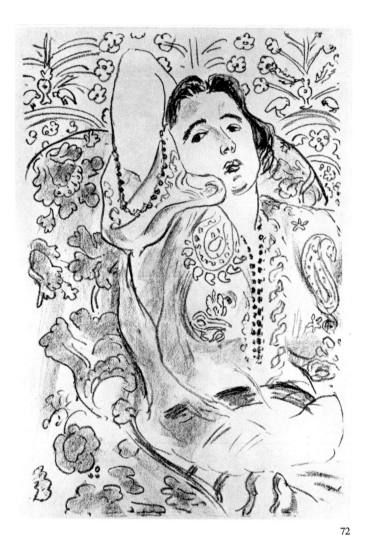

71

72

PLATES 57-65

Kokoschka. Then the artists of Die Brücke, founded in 1905, made the print again a popular art form, avidly published and collected. Schmidt-Rottluff, Otto Müller, Kirchner, and Heckel took up lithography two years later, never to relinquish it.

Many of these artists preferred to work on lithographic transfer paper, which could be handled like a page in a sketchbook, without bothering with the reversal of the image. The crayon and tusche, however, lose in the transfer; unless they are worked over on the stone, they often appear gray and flat.

COLORPLATES 7-10

Lithography has been recognized as an ideal medium for the painter, because it allows great freedom in "painting on stone," and it provides a receptive surface with an infinite variety of tonal values through the use of washes, crayon and tusche, rubbing inks, acids, and scraping tools. Lithography is now firmly established in all the art centers of the world. The master printer has become part of an honorable tradition carried over from the early nineteenth century. Perpetuated in the Paris workshops of Fernand Mourlot, Desjobert, and others, this tradition has been transplanted to other countries as the popularity of the medium skyrockets.

PLATES 92-123

Lithography in America

Lithography came to the New World probably in 1818, when Bass Otis, a portrait

71 *Henri Matisse (1869–1954).* Le Boa Blanc. *Lithograph. Fogg Art Museum, Harvard University, Cambridge, Mass.*

72 *Henri Matisse.* Arabesque. *Lithograph. Brooklyn Museum, New York*

73 *Pablo Picasso.* Portrait of Kahnweiler. *1957. Lithograph. Fogg Art Museum, Harvard University, Cambridge, Mass.*

74 *Pablo Picasso.* The Dancers. *1954. Lithograph. Fogg Art Museum, Harvard University, Cambridge, Mass.*

73

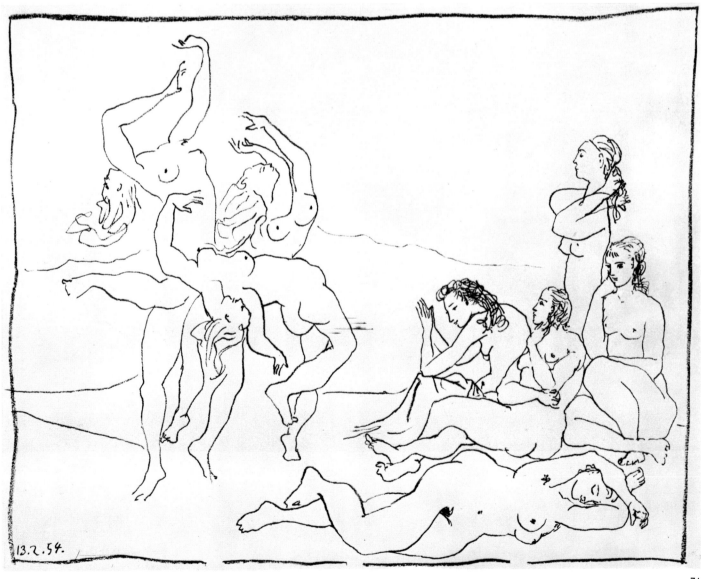

74

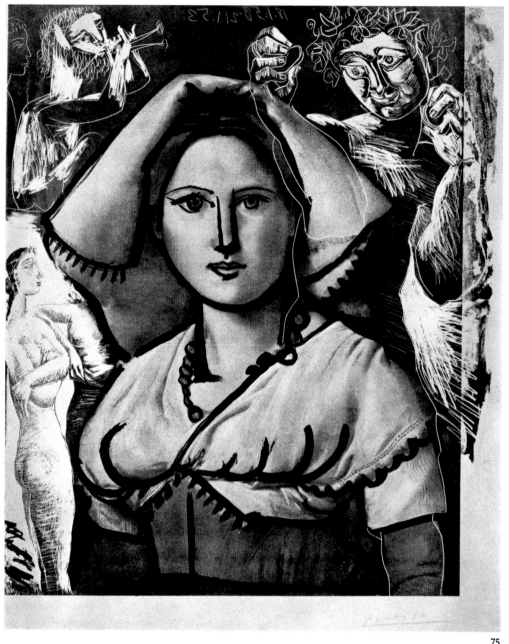

75

76

75 *Pablo Picasso (after Victor Orsel).*
L'Italienne. *1953. Modified*
photolitho plate, 17 1/2 × 13 7/8".
Collection Alexander Dobkin, New York

76 *Alberto Giacometti (1901–66).* Two
Nudes, *from* Derrière le Miroir,
Maeght, Paris. Lithograph. Brooklyn
Museum, New York

77 *Pablo Picasso.* Study of Profiles.
1948. Lithograph, 28 7/8 × 21 5/8".
Museum of Modern Art, New York
(Louise R. Smith Fund)

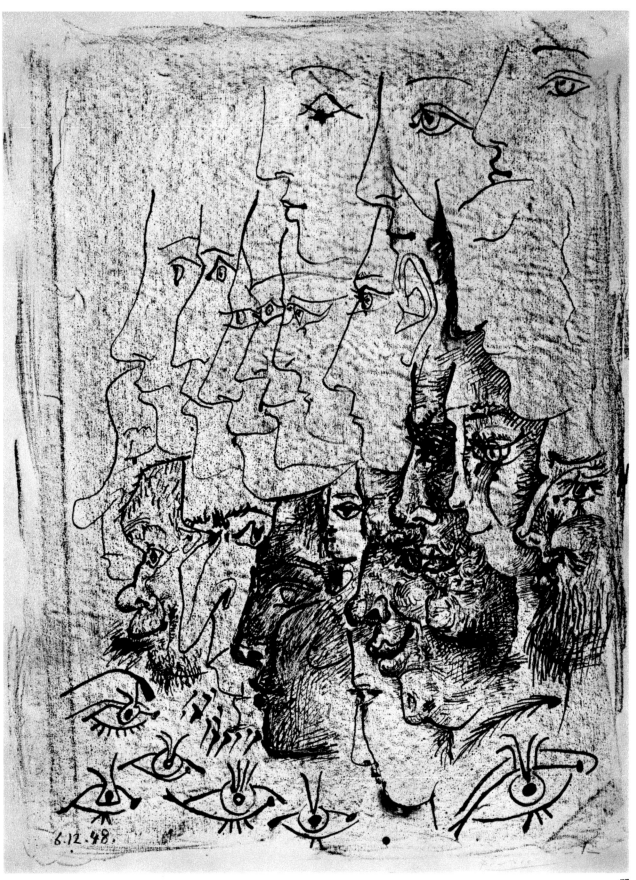

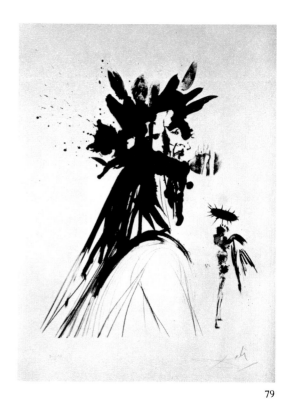

79

78

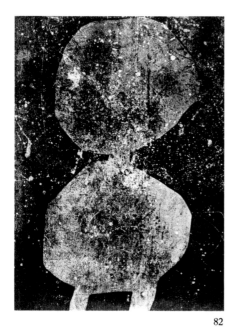

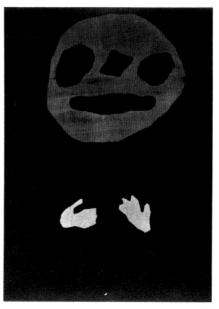

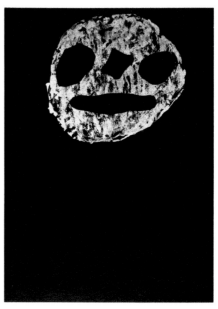

82

83

84

78 *Jules Pascin (1885–1930). Le Lever. Lithograph, 10 × 7 1/2". Courtesy Associated American Artists, New York*
79 *Salvador Dali. Portrait of Dante. c. 1966. Lithograph, 27 1/2 × 21 1/4". Courtesy Associated American Artists, New York*

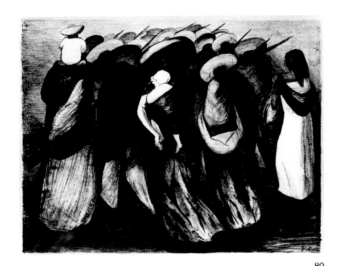

80

*80 José Orozco. Rear Guard. 1929. Lithograph. Philadelphia
 Museum of Art*
*81 David Siqueiros. Peace. 1947. Lithograph, 11 3/4 × 9".
 Courtesy Associated American Artists, New York*
*82–87 Jean Dubuffet. Figure in Red. 1961. Color
 lithograph, 26 × 20". Museum of Modern Art,
 New York (gift of Mr. and Mrs. Ralph F. Colin)*
82 Progressive proof of first five colors
83 Proof of sixth color
84 Proof of seventh color
85 Progressive proof of first seven colors
86 Proof of eighth color
87 Final print

81

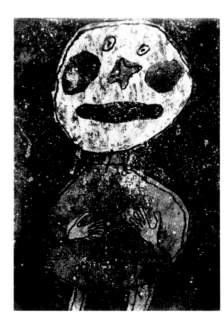

85 86 87

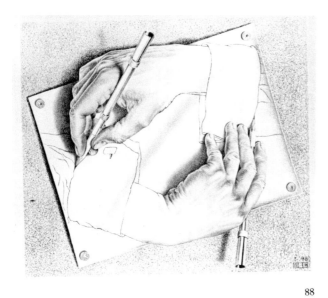

88

89

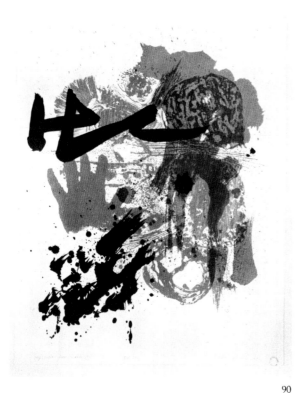

90

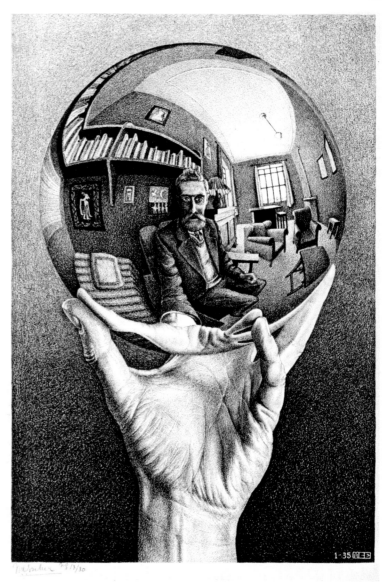

91

88 *Maurits Cornelis Escher*. Drawing Hands.
 1948. Lithograph. National Gallery of Art,
 Washington, D.C. (Rosenwald Collection)

89 *José Luis Cuevas*. Lo Feo de Este Mundo
 III. *Lithograph, 21 1/4 × 27 1/8″.*
 Courtesy Pratt Graphics Center, New York

90 *Chizuko Yoshida*. Impression from India.
 1960. Color lithograph. Courtesy Pratt
 Graphics Center, New York

91 *Maurits Cornelis Escher*. Hand with
 Reflecting Globe *(self-portrait). 1935.*
 Lithograph. National Gallery of Art,
 Washington, D.C. (Rosenwald
 Collection)

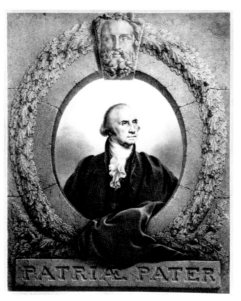

92 *Rembrandt Peale.* George Washington.
*1827. Lithograph. Philadelphia
Museum of Art*

93 *Bass Otis.* Landscape. *1819. Lithograph.
Philadelphia Museum of Art*

94 *William H. Brown (1808–83).* Daniel
Webster, *from the series* Portrait Gallery
of Distinguished American Citizens.
*Lithograph. Brooklyn Museum, New
York*

92

93

94

painter from Philadelphia and pupil of Gilbert Stuart, began to experiment with the *PLATE 93*
new medium. His illustrations for the *Analectic Magazine,* done in the manner of a
copperplate, are probably the first lithographs done on American soil. The first book
so illustrated was Smith's *Grammar of Botany,* published by James V. Seaman, New
York, 1822, and printed by the first lithographic print shop in New York, Barnet
and Dolittle.

Rembrandt Peale, well-known portrait painter, commemorated the Father of
His Country on stone, for which he won a medal from the Franklin Institute in *PLATE 92*

95 *Thomas Moran (1837–1926).* Forest Landscape. *Lithograph. Museum of Fine Arts, Boston*

96 *William Rimmer (1825–74).* Odalisque. *Lithograph. Museum of Fine Arts, Boston*

Philadelphia in 1827. This lithograph was printed by the pioneers of the new medium, the brothers Pendleton, at 9 Wall St., New York.

It was John Pendleton who had brought over from France a ton of lithographic stones, transfer paper, ink, and crayons. More important, he imported a French artist and pressman, thus enabling him to open a print shop in Boston in 1825. He was also instrumental in interesting other enterprising men, such as Kearny and Childs in Philadelphia, Peter Maverick of New York, and a French artist and former naval officer, Anthony Imbert, in the new medium. A few years later John Pendleton sold out to Nathaniel Currier, a former apprentice at the Boston print shop. This was

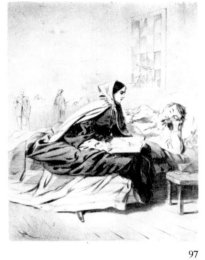

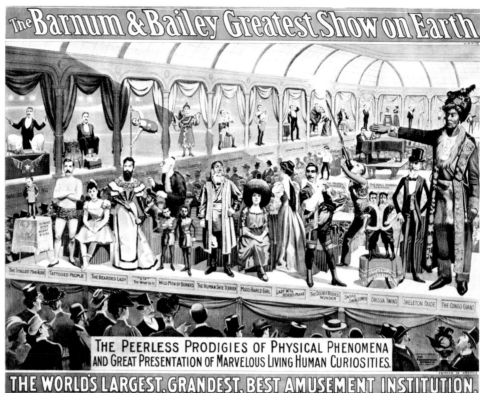

97

98

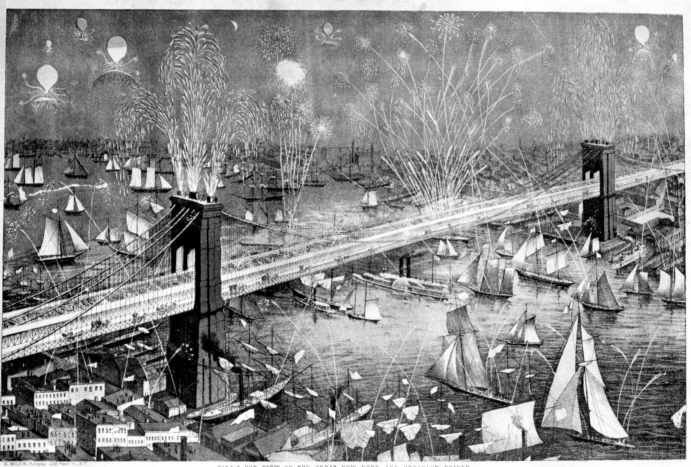

99

the beginning of the famous firm later known as Currier & Ives. Currier started his business in 1834 in Boston but moved to New York two years later. James Merritt Ives joined the firm as an accountant and artist in 1852 and became a partner in 1857. The famous establishment lasted until Nathaniel Currier's son sold out in 1907, after photography had dealt the final blow to documentary lithography.

It was not so much the artistic quality of Currier & Ives's lithographs as the fact that they recorded mid-nineteenth-century American life with such flamboyance and in such loving detail that made them documents of continuing historical interest. They depicted nearly every aspect of the American scene—famous views, great disasters, pioneer life, Indian fights and buffalo hunts, political events and cartoons, portraits of celebrities, historic episodes, homely domestic scenes, sentimental, humorous, and patriotic subjects, popular riverboats, trains and racehorses, and sporting events. It is estimated that the Currier & Ives output may have totaled seven to eight thousand prints. The smaller ones sold for six cents wholesale, with larger prints and folios priced from fifteen cents to three dollars. Mr. Currier and Mr. Ives had found the lucrative secret of appealing mostly to a wider middle-class audience. Prints were sold on the streets of New York by hawkers and from pushcarts, but eminent customers, such as the Prince of Wales or P. T. Barnum, were also accommodated at the popular Nassau St. shop.

A group of artists, often selected for their special gifts for portraying particular subject matter, was employed at very low rates, and no royalties were paid. But then ten dollars may have been a handsome sum in those days for the outright purchase of a plate.

Lithography in America remained popular to some extent even after the decline of Currier & Ives, mainly in the form of posters on billboards and as political cartoons in magazines such as *Puck* and *Harper's* and *Leslie's* weeklies.

When photoengraving began to make its inroads as a quicker and more faithful

COLORPLATE 11

PLATES 98-100

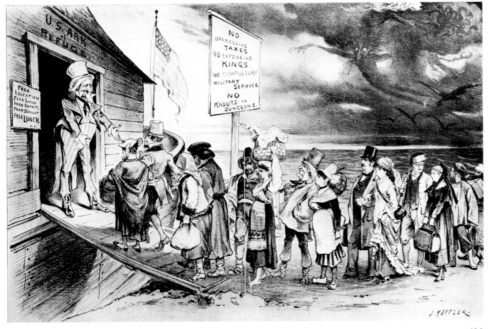

97 *Winslow Homer (1836–1910).* The Letter from Home. *Lithograph. Philadelphia Museum of Art*

98 *Anonymous American.* Poster for Barnum & Bailey circus. *Late 19th century. Color lithograph. Library of Congress, Washington, D.C.*

99 *Anonymous American.* Bird's-eye View of the Great New York and Brooklyn Bridge and Grand Display of Fireworks on Opening Night. *1883. Lithograph. Brooklyn Museum, New York*

100 *Joseph J. Keppler (1838–94).* Welcome to All!, *from* Puck. *Lithograph. New York Public Library, Astor, Lenox and Tilden Foundations*

100

PLATES 95, 97, 104

method of reproduction about the turn of the century, lithography was kept alive as an art medium by some well-traveled and well-known artists, including Whistler and Joseph Pennell. Marsden Hartley and Max Weber followed suit, but the artists of the so-called "Ash Can School" of social comment, John Sloan, Everett Shinn, George Luks, and others around them, seemed to prefer the more incisive etching.

PLATE 105

PLATES 102, 103

PLATES 106, 107

Nevertheless, powerful shadows of Daumier's work reached across the decades. George Bellows led another generation of *engagé* artists with a series of powerful lithographs (ably printed by George Miller); William Gropper, Hugo Gellert, and others on the left took up the political cudgel; Raphael Soyer covered the sweatshops of the garment district; Reginald Marsh, the Bowery; Ben Shahn, the militant labor unions (he had served as a lithographic apprentice in his younger days).

PLATE 109

Adolf Dehn devoted his whole life to exploring his favorite medium, lithography, in which he recorded his travels around the world.

PLATE 108

During the Depression the Federal Art Project saw Stuart Davis, Louis Schanker, Yasuo Kuniyoshi, Louis Lozowick, and others lifting the lithograph to a more prom-

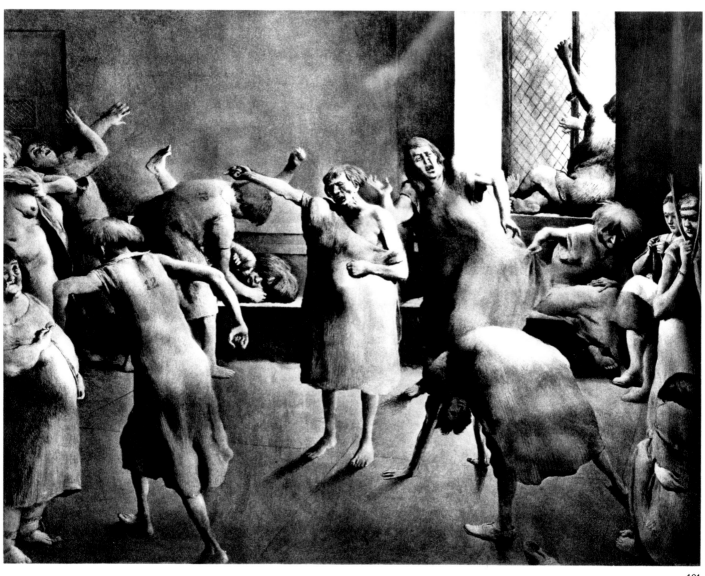

101 *Robert Riggs*. Psychopathic Ward. *1945. Lithograph. Philadelphia Museum of Art (Ars Medica Collection)*

102 *Raphael Soyer*. The Mission. *1933. Lithograph, 12 1/8 × 17 5/8". Philadelphia Museum of Art (Carl Zigrosser Collection)*

103 *Raphael Soyer*. Self-portrait. *1933. Lithograph, 13 1/4 × 9 3/4". Yale University Art Gallery, New Haven, Conn. (gift of Mrs. Laurent Oppenheim)*

104 *James A. McNeill Whistler*. The Thames. *1898. Lithograph, 10 1/2 × 7 5/8". Philadelphia Museum of Art*

105 *George Bellows (1882–1925)*. Hungry Dogs. *1916. Lithograph. National Gallery of Art, Washington, D.C. (Rosenwald Collection)*

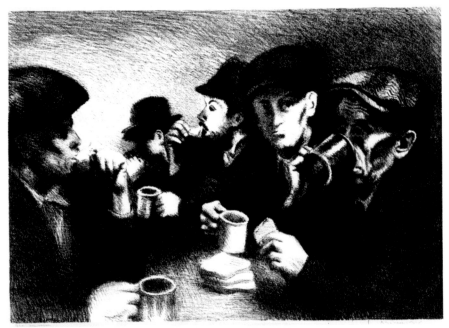

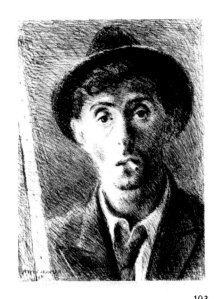

102

103

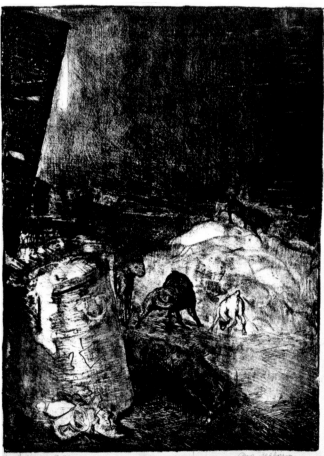

104

105

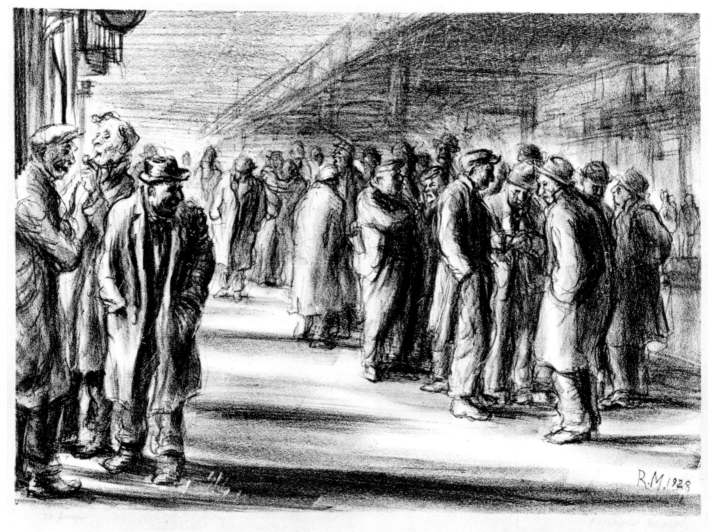

106

PLATES 110, 111, 114
PLATE 112

COLORPLATE 12
PLATES 113, 118

inent place in the graphic arts. The trio of regional artists, Thomas Hart Benton, Grant Wood, and John Steuart Curry favored lithography for their rustic revival of homespun scenes of Middle America. The medium had become respectable. Charles Sheeler used it in his austere portraits of the industrial and urban landscape, as Stow Wengenroth celebrated bucolic New England.

Artists such as Rico Lebrun, Ivan Albright, Emil Weddige, and Benton Spruance greatly contributed to the resurrection of the medium as well. Today it has found its rightful place again through the evangelistic zeal of such devotees as June Wayne of the Tamarind Workshop and Tatyana Grosman of Universal Limited Art Editions. The most prominent artists of today, from Vasarely to Oldenburg, have been initiated into the mysteries of the stone or plate with often impressive results.

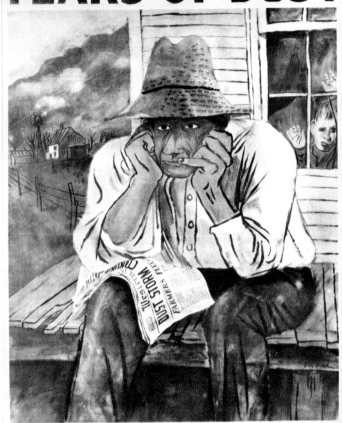

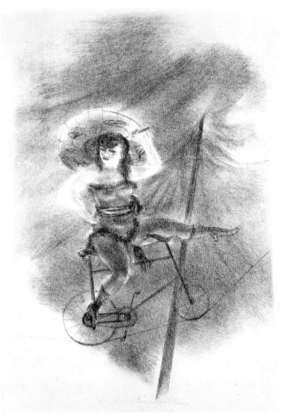

107

108

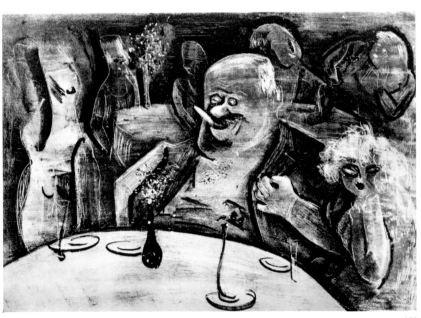

109

106 *Reginald Marsh. Bowery. 1928.*
 Lithograph, 8 1/4 × 11 3/4". Yale
 University Art Gallery, New Haven, Conn.
 (gift of the artist)
107 *Ben Shahn. Years of Dust. c. 1936. Color*
 lithograph, 38 × 25". Library of
 Congress, Washington, D.C.
108 *Yasuo Kuniyoshi (1893–1953). The*
 Cyclist. Lithograph, 13 1/2 × 9 1/4".
 Yale University Art Gallery, New Haven,
 Conn. (gift of Mrs. Laurent
 Oppenheim)
109 *Adolf Dehn. All for a Piece of Meat.*
 Lithograph. Brooklyn Museum, New York

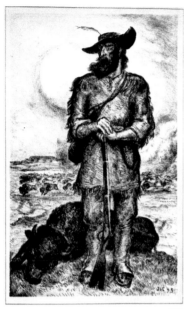

110

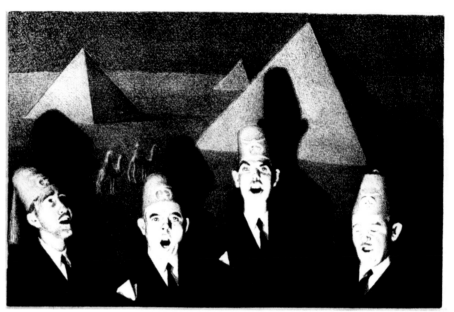

111

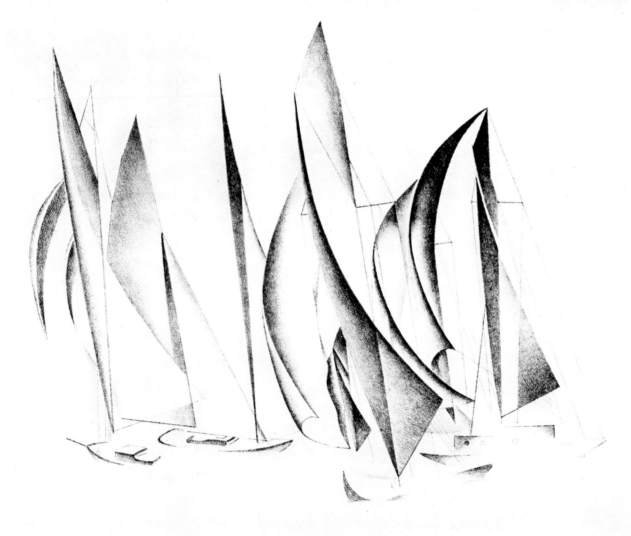

112

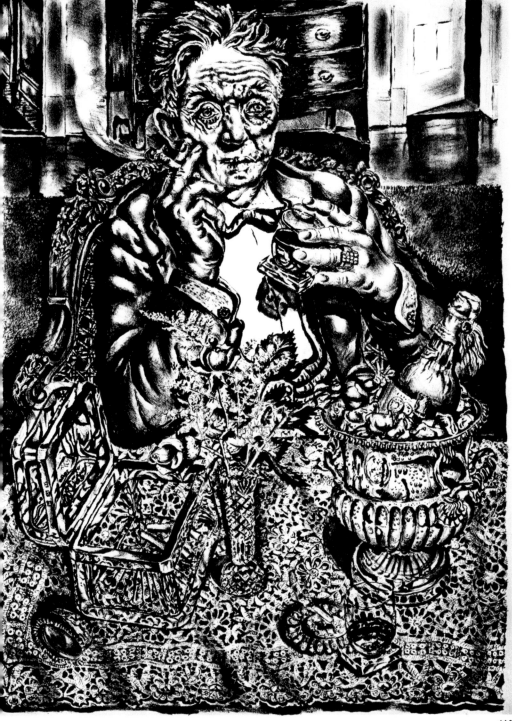

110 *John Steuart Curry*. The Plainsman.
1945. Lithograph, 16 1/2 × 10 1/4".
Courtesy Associated American Artists,
New York

111 *Grant Wood*. Shriners' Quartet. *1939.*
Lithograph, 7 7/8 × 11 3/4".
Courtesy Associated American Artists,
New York

112 *Charles Sheeler*. Regatta. *1924.*
Lithograph, 8 1/2 × 10 3/4". Courtesy
Associated American Artists, New
York

113 *Ivan Albright*. Self-portrait: 55 East
Division Street. *1947. Lithograph,*
14 1/4 × 10 1/8". Courtesy Associated
American Artists, New York

114 *Thomas Hart Benton*. Cradling Wheat.
1939. Lithograph, 9 3/4 × 12".
Philadelphia Museum of Art (Carl Zigrosser
Collection)

115 *Jackson Pollock*. Harvesting Scene. *1937.*
Lithograph, 9 1/2 × 12 3/4". Courtesy
Associated American Artists, New York

113

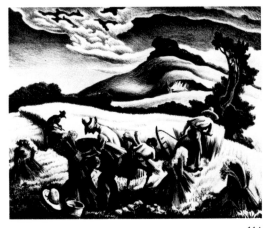

114

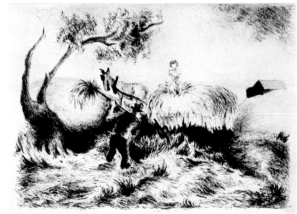

115

116 *Grace Hartigan.* Inside—
Outside. *1962. Lithograph.*
Brooklyn Museum, New York
117 *Robert Gwathmey.* Matriarch.
c. 1963. Color lithograph.
Brooklyn Museum, New York
118 *Rico Le Brun.* Moonlit Earth.
1945. Lithograph. Brooklyn
Museum, New York

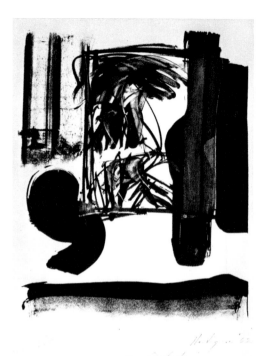

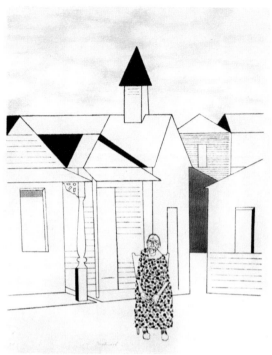

116

117

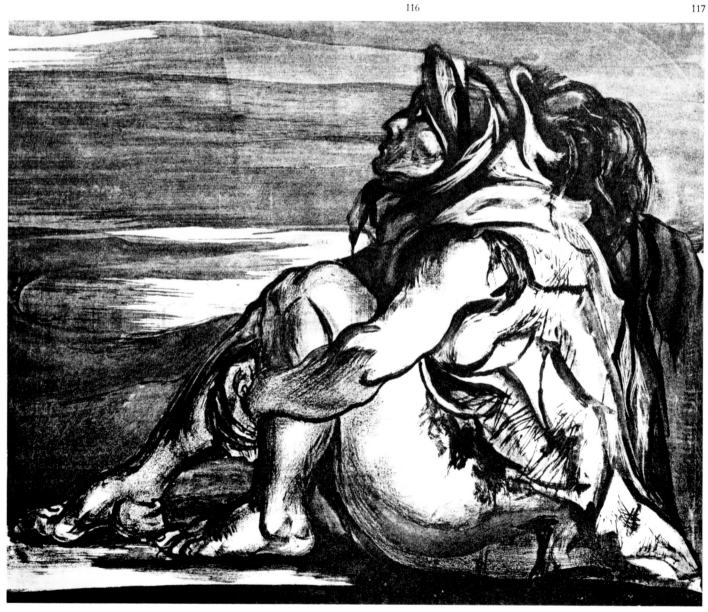

118

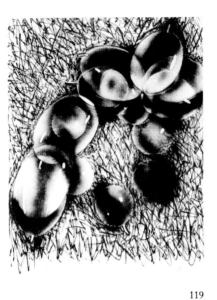

119

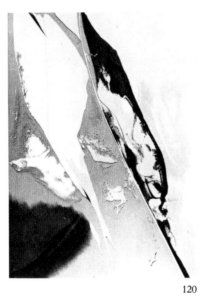

120

119 *Jim Rosenquist. Bunraku. 1970. Color lithograph, 32 × 23 1/2". Courtesy Castelli Graphics, Inc., New York*

120 *Paul Jenkins. Untitled. 1967. Color lithograph, 28 × 20". Courtesy Pratt Graphics Center, New York*

121 *Philip Pearlstein. Nude. Lithograph. Courtesy Pratt Graphics Center, New York*

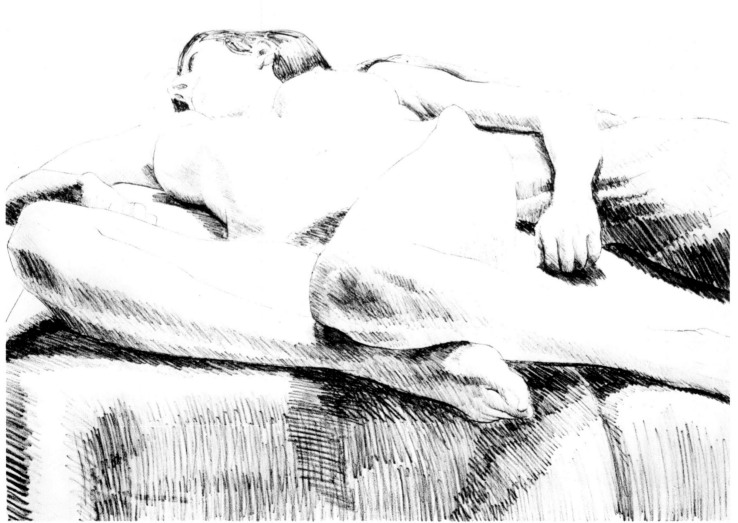

121

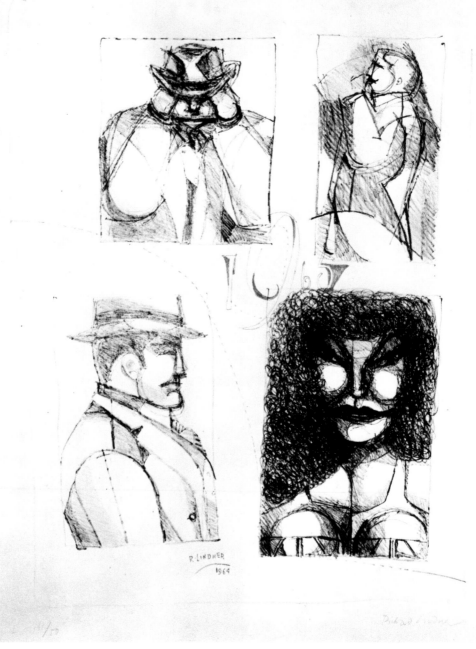

122

123

122 *Richard Lindner. Untitled. 1964.*
 Color lithograph. Collection
 the author
123 *Frank Stella.* Black Series II.
 1967. Lithograph. Philadelphia
 Museum of Art

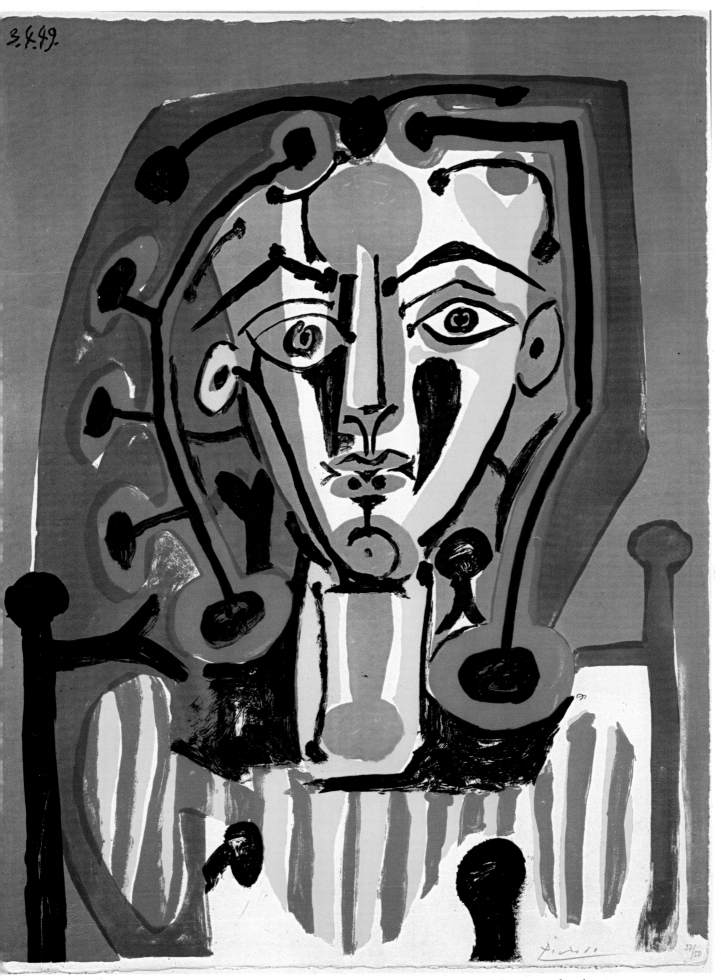

9 *Pablo Picasso*. Figure au Corsage Rayé (The Striped Blouse). *1949. Color lithograph, 25 1/2 × 19 3/4". Museum of Modern Art, New York (gift of Abby Aldrich Rockefeller Fund)*

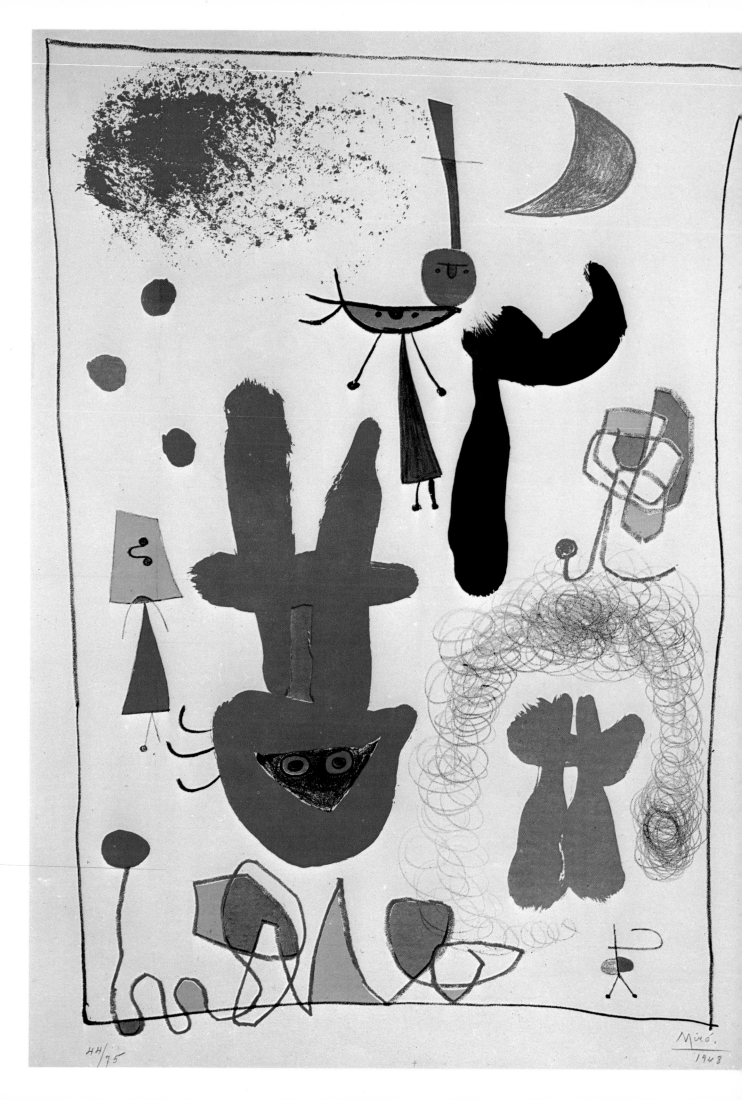

HH/75

Miró.
1948

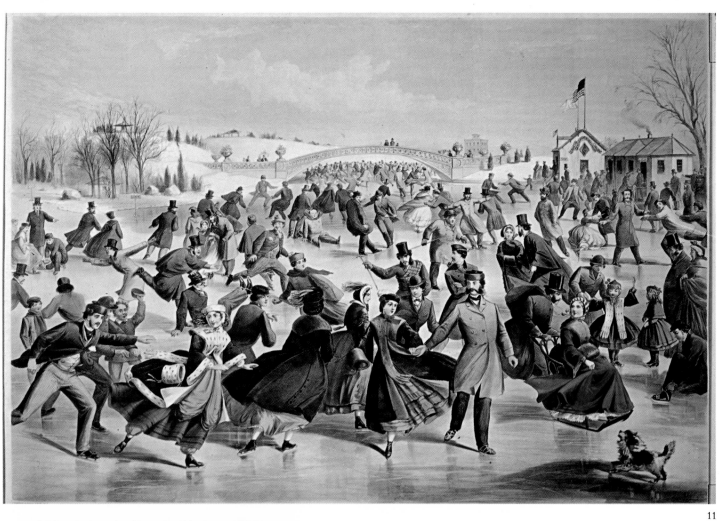

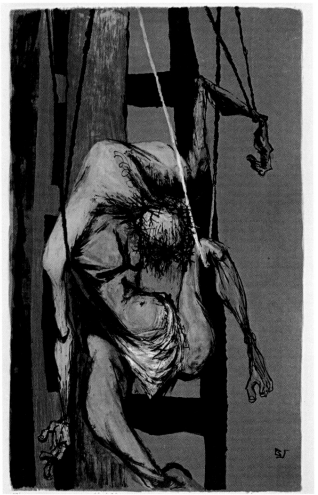

10 *Joan Miró.* Acrobats in the Garden at Night.
1948. Color lithograph, 21 3/4 × 16 1/8".
Museum of Modern Art, New York

11 *Charles Parsons.* Central Park, Winter: The
Skating Pond. *Second half of 19th century.*
Colored lithograph, published by Currier & Ives.
New York Public Library, Astor, Lenox and
Tilden Foundations (Prints Division)

12 *Benton Spruance.* Black Friday. *1958. Color*
lithograph, 21 1/4 × 12 1/2". Yale University
Art Gallery, New Haven, Conn. (gift of
George H. Fitch)

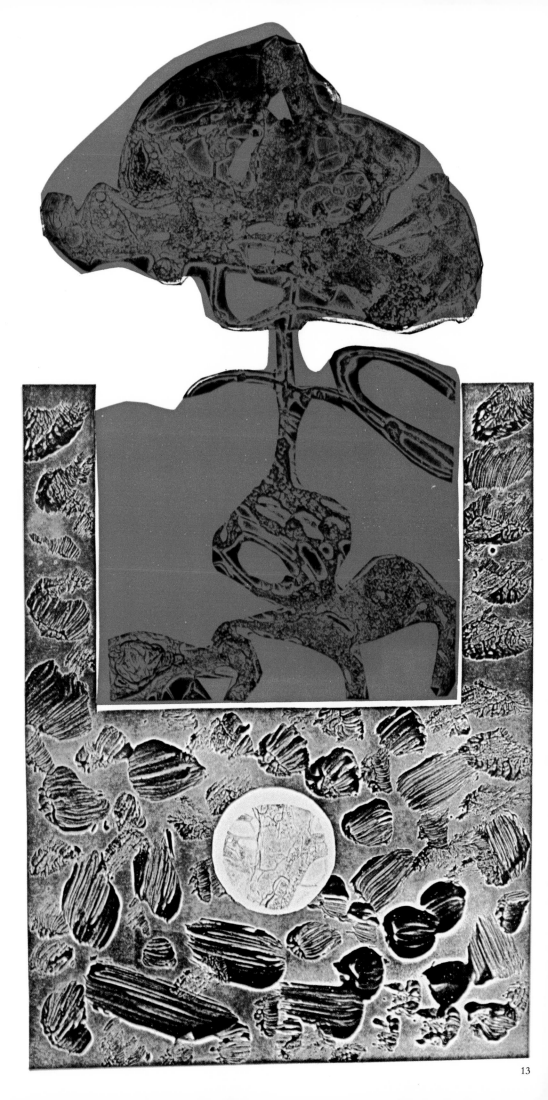

13 Tadeusz Lapinski. Mother Nature.
 1970. Color lithograph, 24 × 12″,
 with progressive proofs 1 and 2.
 Courtesy the artist
14 Paul Wunderlich. Models in the
 Studio. *1969. Color lithograph.*
 Collection the author

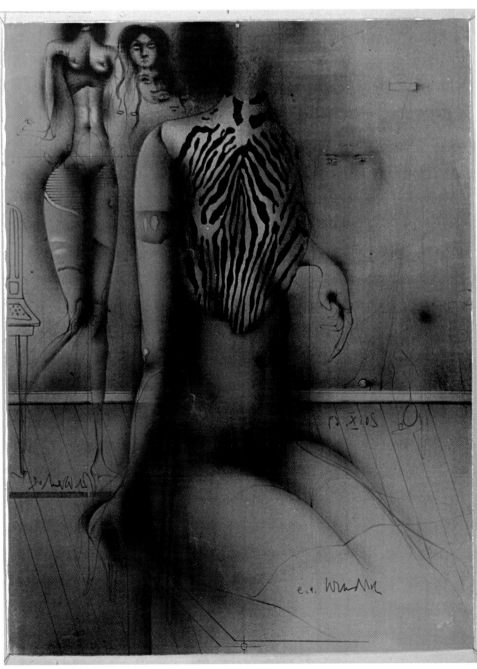

15 *Christian Kruck. Untitled (final print, with
progressive proofs 1–4). Color
lithograph, 22 7/8 × 28 3/8". Courtesy the
artist*

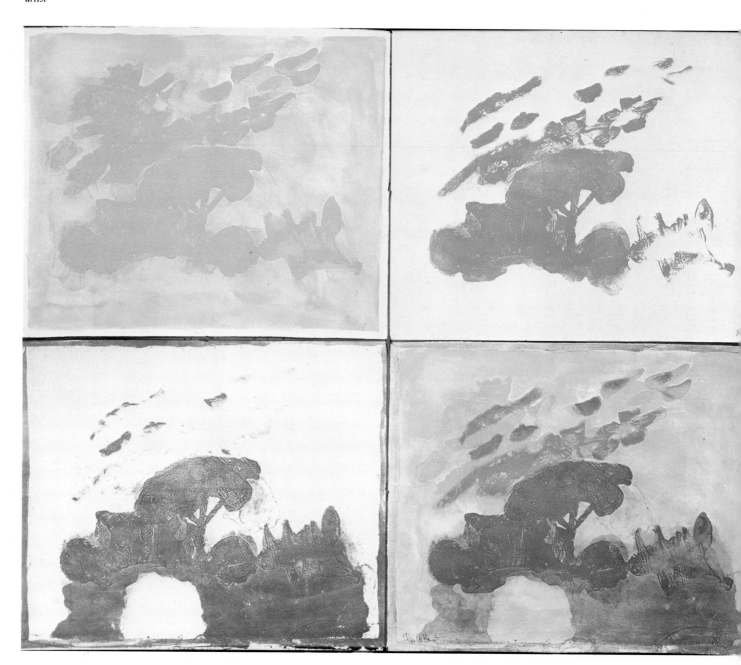

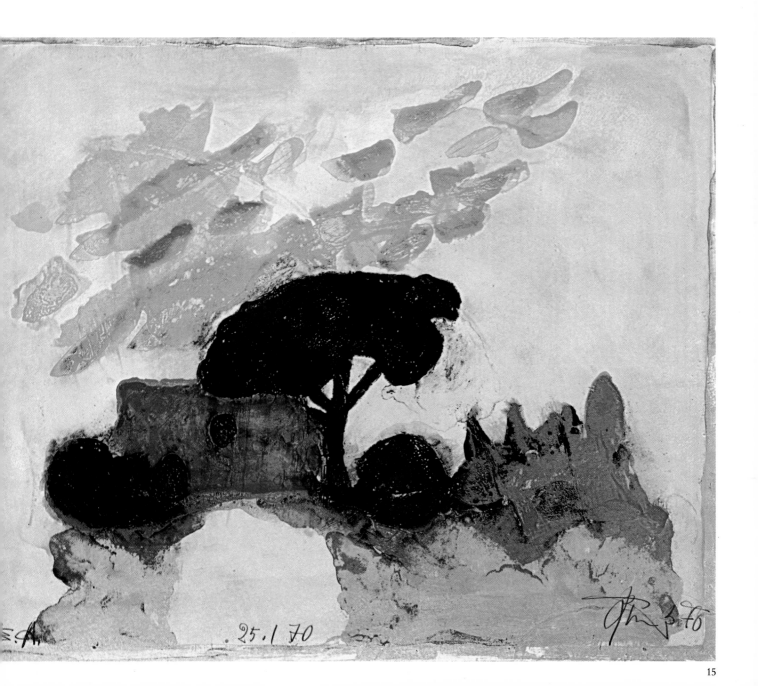

25.1 70

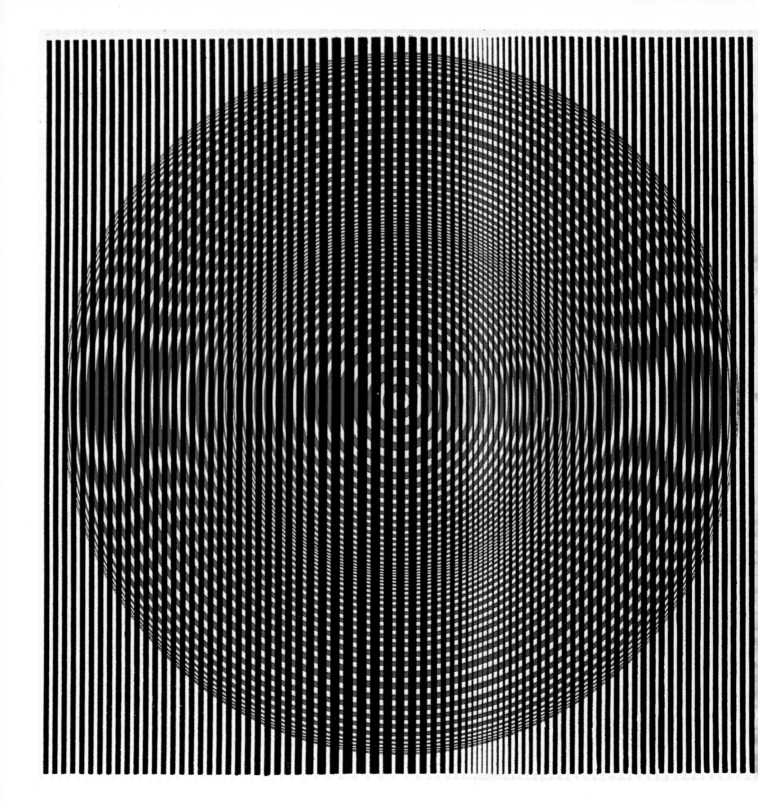

16 *Reginald Neal. Red Circle Moiré No. 2. 1965. Color lithograph, 11 5/8 × 11 5/8". Courtesy the artist*

CHAPTER 2
LITHOGRAPHY

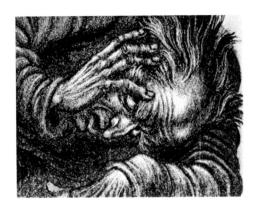

Technique

Although the basic principle involved in the making of a lithograph is the antipathy of grease to water, the quality of the finished print is actually determined by the delicate, complex relationship between the materials used and by the skill with which the artist can manipulate and control the various chemical reactions. In addition, the printmaker must concern himself with problems of cleanliness, adequate space for working, drying, and storing, control of climate and temperature, and so on. The slightest intrusion of grease or dampness in the wrong place or at the wrong time can result in the ruin of the finished print.

PLATE 124

The press is the focal point of the workshop, with inking slabs, water supply, paper, and storage space arranged conveniently around it. The sink used for the graining of stones should be well away from both greasy materials and clean paper and proofs. The size and weight of the stones make it necessary to have work surfaces of a comfortable height, and often a fork lift is used to move stones from one place of action to another.

Preparing the Stone

The best lithographic limestone comes from Solnhofen, in Bavaria; it has been found to be relatively free from flaws and resistant to cracking in the press. The slabs, varying in thickness from 2 1/2 to 4 inches, depending on the size of the printing surface, can be grouped in three grades of hardness. The yellow stone is softest; its grain tends to deteriorate under pressure. The gray is of medium hardness. The bluish stone, almost as hard as slate, is well suited for work involving fine detail, such as pen drawing and engraving.

The texture of the grain is determined by the abrasive agent used in preparing the stone surface. Even a new stone will have to be grained for the particular type of work to be done. In the case of a reused stone all traces of the old image must be removed and a new grain established. The "ghost" of the old image can often be seen if the stone is examined closely; the graining process must be repeated until every trace is eliminated.

The stone is placed in the graining sink, generally a wooden structure lined with lead or fiber glass. The stone rests on a wooden rack at the bottom of the sink. The edges of the stone must be beveled slightly with a file; this prevents ink from accumulating at the edges during printing. The actual grinding can be done either with a levigator, a cast-iron disk with a wooden handle, or with another litho stone of manageable size. The surface of the stone is thoroughly dampened and sprinkled with one or two spoonfuls of Carborundum (silicon carbide) grit (No. 180 is recommended for the first graining). If a stone is used for the grinding, it should be moved evenly, without pressure, over the entire surface of the stone to be prepared. Care should be taken to grind all parts of the surface uniformly. After a few minutes a creamy sludge is formed, and the graining stone becomes harder to move. At this point the top stone should be moved slowly to one edge of the bottom stone and removed. Both stones are now thoroughly washed and checked for scratches and, with a metal straight edge, for flatness. A few oversized grains mixed in with fine grit will cause ugly scratches in the stone's surface. This process is repeated until no "ghost" is visible and finished off with a graining of very fine (No. 220 F or FF) grit. After washing, the stone will appear quite smooth, but a microscope would reveal a surface of tiny pits and crags. When the artist is satisfied with the surface, the stone

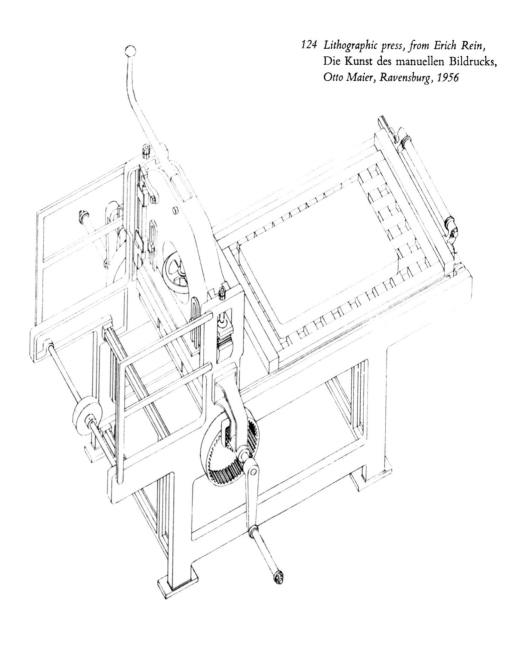

124 *Lithographic press, from Erich Rein,*
Die Kunst des manuellen Bildrucks,
Otto Maier, Ravensburg, 1956

should be propped at an angle and washed down. The clean, freshly grained surface is extra-sensitive to both grease and water at this point. If the stone is not to be used immediately, a clean sheet of paper should be taped over the surface to protect it.

Drawing on the Stone

As Senefelder discovered, almost any greasy substance can be used to draw on the litho stone; in fact, he showed that the image can be drawn even in water-soluble ink, the stone desensitized to water, and the printing done with water-base ink. The drawing materials most often used today are litho crayons, tusche, and rubbing ink. Both crayons and tusche are composed of a mixture of carnauba wax (hard), beeswax (soft), lampblack, and castile soap. Crayons come in various shapes and sizes and range in hardness from No. 00 (very soft) to No. 5 (called "copal," very hard). Tusche comes in both premixed liquid form and solid. Solid tusche can be mixed with turpentine, gasoline, or water to the desired consistency. Rubbing ink, containing a

PLATES 125, 126

125

high proportion of beeswax, is soft and can be applied directly to the stone with the fingertip. Tusche thinned with distilled water and applied with a brush produces a wash effect.

High lights can be erased or scraped out of dark areas with razor blades, needles, knives, or steel wool. The range of effects that can be achieved by these means is literally limitless. (See Chapter 3.) In variety of line, tone, and texture lithography offers perhaps the widest possibilities of any print medium.

For tracing a design on the stone, the back of the paper may be covered with Conté powder or crayon (red). The paper is laid upside down on the stone, and the design traced with pencil. The impression on the stone can then be worked over with grease crayon or tusche. Emil Weddige refers to a gum-arabic-coated paper which

125 *Fritz Eichenberg. Illustration for Dostoevski,* The Brothers Karamazov. *1949. Drawing, 8 1/2 × 6 1/2".
Collection the author*

126 *Fritz Eichenberg. Illustration for Dostoevski,* The Brothers Karamazov. *1949. Lithograph, 8 1/2 × 6 1/2".
Collection the author*

126

can be drawn on with crayon or tusche. When slightly dampened with a sponge or damp book and run through the press several times, the paper will leave a reversed image on the stone and will have automatically desensitized blank areas to grease. One disadvantage of this procedure is that it makes additions or corrections impossible, unless certain areas are resensitized or resurfaced. Transfer papers without the gum-arabic coating can be used in the same way.

The transfer method is preferable for subjects that should not be printed in reverse (such as lettering). It is also practical because corrections can easily be made on the paper; areas can be cut out or blocked out by painting over with Chinese white before the image is transmitted to the stone.

Throughout the drawing stage great care should be taken to prevent soiling

blank areas and margins. Fingerprints may show up as black marks on the print. Areas intended to be pure white can be protected with a mixture of gum arabic and a small amount of nitric acid, which will prevent smudging even if crayon or tusche is accidentally applied over the gum.

The completed transfer drawing should be dusted with French chalk, applied with a clean cloth or puff; this coats the grease image and makes it resistant to the etch. A second dusting with powdered rosin effects a greater affinity between the etch and the surface of the stone. The excess powder should be carefully dusted off; only a fine, almost invisible, layer will remain.

The Etch

Lithography is a planographic process; the image is neither cut into nor significantly raised above the surface of the stone. The printing is achieved by chemical treatment of the image and the blank areas of the stone, which makes the drawing attract ink and the blank areas reject it. The term "etch," applied to treatment of the surface with a mixture of gum-arabic solution and acid, seems somewhat misleading. Gum arabic, a product of the acacia tree, is usually obtained in the form of solid lumps, which are dissolved with enough water to produce a syrupy solution. Strained through cheese-cloth to remove impurities, this solution is mixed with a small amount of nitric acid. Lithographers differ in their "recipes" for the etch (Peter Weaver, 50 to 1; Jules Heller, 1 1/2 ounces gum and 5 to 15 drops acid; Emil Weddige, 8 drops acid to 1/2 cup gum). Since the reaction is influenced by such factors as temperature, humidity, and the condition of the stone, some testing or experimenting is advisable.

The function of the gum is to "set" the drawing, freeing the grease in the crayon or tusche and allowing it to be absorbed deeply into the stone. The greasy areas become more water-resistant, and the entire surface of the stone hardens slightly. The nitric acid opens the pores of the stone, cleans it of minute deposits of dirt, and further desensitizes the blank areas to grease. The more grease there is in the drawing, the stronger should be the etch. Fine or grainy crayon lines will be destroyed if the etch is too strong.

Enough etch to cover the stone should be poured either on the margin or in a blank area. The solution is then spread with the palm of the hand, or with a 3-inch brush if the etch is quite strong, and kept moving over the surface for several minutes. More etch can be poured on, if necessary, and the spreading continued. The etch should produce a mild, rather than a violent, foaming action on the surface. After the stone has been spread with gum and the excess wiped or blotted off, the process is repeated and the gum finally rubbed down to a thin coat. The gum is fanned dry and the stone left to stand overnight.

Washing out the Drawing

After the gummed stone has been allowed to stand for twelve hours, the gum is washed off completely. The surface of the stone should feel very smooth. Now the drawing is lightly sprinkled with turpentine while the stone is still wet, and the black pigment is washed out with a clean cloth. The stone is kept damp by flooding it with water, and more turpentine is sprinkled on as needed. The pigment is washed out until there remains only a faint image on the stone.

Rolling up the Image

Lithographic ink should have body and should be rather slow-drying. If it is too easily soluble in water, it will scum over the drawing when the stone is dampened with a sponge. It must be sufficiently greasy to be attracted by the greasy drawing. The basic components of litho inks are the pigment, a drying agent, a binder, or vehicle, which may be varnish, and linseed oil. In order to adjust the ink to the specific job at hand, it is necessary to understand the properties of the various additives. Linseed oil, for instance, will increase the grease content of the ink; varnish will thin the ink and add tackiness.

A small quantity of the very stiff ink should be placed on the inking slab, thinned slightly with varnish, and worked over with a palette knife until it flattens slowly when gathered together into a pile.

The roller used for inking the stone consists of a wooden core covered with heavy flannel and an outer layer of leather, nap side up. The roller is often used with cylindrical leather "cuffs" over the handles to facilitate rolling and ease friction on the hands.

Rollers must be kept in top condition at all times. A new roller must be conditioned before use. It should be smeared generously with litho varnish, then scraped with a dull table knife or spatula, first against the grain and then with it. The seam of the roller's leather cover should not be scraped, for that causes it to leave a noticeable line on the inked stone. After scraping, the roller should be rubbed with varnish again, this time a harder varnish (No. 6 or 7), which should be worked in with the hands. The roller should then be rolled a few times over a clean ink slab, scraped, and rolled again, until no more nap can be scraped off. Next a small amount of ink should be placed on the slab and the roller rolled over it for 15 to 20 minutes, then scraped, and rolled again. Any roller not in use for a week or more must be protected with aluminum foil or other wrappings or coated with a layer of thick grease, such as Vaseline. This must be scraped off completely before the roller can be used again. If necessary, an old, dried-out roller can be wire-brushed to raise the nap.

The inking of the stone can now begin. The stone is placed in the bed of the press and dampened evenly with a sponge. No excess water should be allowed to remain in pools on the surface, but the stone should never be completely dry during inking. The sponge must be perfectly clean. The roller is charged with ink by rolling it several times back and forth on the ink slab. Then the stone should be dampened again with the sponge and rolled up several times, with only the weight of the roller and with care to start rolling each time at a different place. The roller should also be turned end-to-end from time to time, to insure even inking of the stone. As this procedure—charging the roller, dampening the stone, and rolling up—is repeated several times, the image will slowly "come up" until it appears to have reached full strength. At this point the drawing can be checked for corrections. Unwanted lines must be ground out with pumice or grit, and more work can be added to blank areas if they are first counter-etched, or resensitized with a solution of acetic acid (40 percent) or a saturated solution of alum. The new work must be given an etch and rolled up before printing can proceed.

After the first inking Weddige recommends treating the image with French chalk and rosin and gumming thinly. The stone is placed in a rack for 4 to 6 hours before the printing of the edition proceeds.

The inked drawing may be further "set" or "etched" by burning. Fine asphalt powder is sprinkled over the inked stone; this is then burned in with a special blowtorch. The result is a highly etch-resistant layer covering the drawn areas. The stone is then very strongly etched until the image appears in slight relief. A stone thus prepared will withstand much pressure and can be used for printing unusually large editions, but the prints will show a harder line and less delicate texture than can be achieved without burning.

Printing

The best papers for lithography must have enough body to withstand dampening. They should have softness, a pure texture, and longevity. Among those recommended by contemporary practitioners are Arches, Rives, Basingwerk Parchment, Fabriano Book, Umbria, Shogun, Kochi, and Inomachi. The paper should be prepared for printing by stacking it between damp blotters, wrapping in oilcloth or plastic sheeting, and placing all between two boards overnight. Dampened paper will take ink evenly and deeply.

The press used is essentially of the same scraper type as the one Senefelder constructed. The type most common in Britain and America has a side pressure lever, while a top-lever model is mostly used in Germany. To begin printing, select and put in place a scraper that is larger than the drawn area but not wider than the stone. The wooden scraper, with its edge covered by a strip of leather, must be well greased with tallow or butter. The tympan, or pressboard, is also greased to ensure a smooth passage of the stone through the press.

The pressure is adjusted by moving the stone under the scraper, pulling the lever to ten-o'clock position, turning the top screw until it touches the stone, releasing the pressure, and giving the screw one or two more turns. The stone can now be returned to its original position, and rolled up with ink. The roller must be rolled over the ink slab and onto the stone at least five or more times for each inking. When the image appears fully inked, the sheet of paper is carefully lowered onto the stone, covered with several blotters or sheets of newsprint and the tympan, and pressure is applied. The stone is cranked evenly through the press until the scraper rests on the back margin of the stone. If the scraper is allowed to move suddenly off the edge of the stone, the stone may break. Now the pressure is released, the bed pulled back, and the backing and print removed, one layer at a time. As the print is removed, the stone should be dampened with a sponge. It is now ready to be reinked and printed again. The first few proofs should be pulled on newsprint. Adjustments in inking can then be made until the first acceptable proof appears. The first proofs pulled on good paper will often print light. Since the precise and skillful dampening, inking, and pulling through the press determine the final quality of the print, care should be taken to standardize each step of the process as much as possible, once a good proof has been pulled. Careful attention should be paid to the number of times the roller is applied to the ink slab and to the stone in order to achieve uniformity in the prints.

The stone must remain damp throughout inking and printing, and only a few seconds can elapse between rolling up and pulling the proof. When hot weather

threatens to make it impossible to keep the stone damp enough, many lithographers add a small amount of stale beer to the water to retard evaporation.

As the desired number of proofs is pulled, a constant watch should be kept to ensure that all prints are up to the standard of the first good proof. When the printing of an edition has been finished, the stone may be canceled by rubbing, scraping, or scratching the image. The prints may be hung up or placed under a press to dry.

The possibilities for individual experimentation are endless; the artist is limited only by his imagination and by the skill with which he can control his materials and equipment.

Metal-plate Lithography

As Senefelder realized, many substances other than stone can be adapted for lithography. Ready-grained zinc and aluminum plates, usually 1/5 to 1/4 inch thick, are popular, because they are relatively cheap and are lighter and easier to store and handle than stone. Since the supply of fine-grained limestone from Bavaria seems to be nearly exhausted, and demand for lithographic materials is rising sharply, metal plates will come more and more into use. The advantages of zinc and aluminum plates, however, are somewhat offset by the extra care needed in working on them. Certain techniques, such as scratching and scraping, cannot be used on metal at all.

Before drawing on the plate, the artist must subject the surface to a counter-etch, to make the metal sensitive to grease. The plate is immersed in a saturated solution of powdered alum and water, sometimes with a small amount of nitric acid added. The solution is kept moving over the surface of the plate for several minutes. Then the plate is washed with clean water and dried immediately to avoid oxidation, which would render the plate insensitive to both grease and water.

The procedure from this point parallels stone lithography, except that in the formula for the gum etch small amounts of chromic and phosphoric acid are substituted for nitric acid.

The gum etch, the grease crayon, and the water all lie on the surface of the metal plate rather than penetrate it, as they would a litho stone. (Great care must be taken not to disturb their somewhat tenuous hold.) Some lithographers suggest a second etch, after the first roll-up with ink, to clean and fully desensitize the plate.

The printing proceeds exactly as in stone lithography.

Color Lithography

The first departure from simple monochrome lithography was Hullmandel's "Litho-tint" process, developed in his London workshop. The image was printed from two or more stones in neutral colors, in effect imitating a wash drawing. Godefroy Engelmann, in Paris, began printing in "chromolithography," in which a separate stone was used for each color, creating an endless variation by overprinting.

This color process was soon adopted by commercial lithographers with spectacular, though often garish, results. Ironically, while mass-produced chromolithography signaled the temporary demise of lithography as a creative medium, many outstanding lithographers, from Toulouse-Lautrec to Wunderlich, have worked most successfully in color lithography.

COLORPLATE 13

The basic procedure is the same as in monochrome. The artist can range as widely as his knowledge of color and of the chemistry of inks will allow. Some contemporary lithographers, including Christian Kruck, have printed several colors from one stone, either in succession or simultaneously.

The artist must first analyze his proposed design, visually breaking it down into its component colors. He must consider possibilities of overprinting, noting the various degrees of opaqueness or transparency of his inks, and must remember that the order in which the colors are printed will have a great bearing on the final result. A lengthy period of experimentation with various inks and with sequences of printing is of primary importance.

The overall outlines of the design are first drawn or transferred onto a stone, a blue proof is pulled with watercolor ink, and this in turn transferred to as many stones as are to be used. Registration marks, in the form of small crosses, usually placed in diagonal corners of the stone, are included in the drawing.

Now the stone is drawn, etched, and inked with the first color, often the dominant or most prominent one in the design. The roller used is not nap leather but rubber-covered, generally over an aluminum core. Enough proofs of the first color are pulled to make up the desired edition. Another stone is drawn and inked for the next color, and the proofs are registered on the stone by cutting or punching a small circle at the intersection of the cross marks or a triangle enclosed within adjacent arms of the cross to indicate edge limits. The paper can be laid on the stone so that one cross lies exactly over the other. Another method is to pierce the center of the crosses on the paper with pins or needles mounted in wooden handles and, centering the needle points on the stone's registration marks, to lower the paper gently in place.

Most lithographers prefer to use dry paper for color printing, because paper will stretch unevenly when dampened, making accurate registration difficult, if not impossible.

The production of a uniform edition of color lithographs requires the utmost precision in each step of printing; each motion must be closely duplicated. The rigid discipline of the technique has led most artists to entrust the production of their color editions to skilled professional printers.

CHAPTER 3

NOTES ON LITHOGRAPHIC TECHNIQUES

by Prominent Printmakers

Ranging from traditional procedures to the adoption of highly unorthodox methods and of recently developed devices, the procedures outlined below exemplify some of the diversity of styles and effects practiced today by artists in the lithographic medium.

STOW WENGENROTH
Crayon Lithography

PLATE 127

I spend nearly as much time on the preliminary drawing as in working on the stone. The first drawing I do directly from nature, in dry-brush watercolor to give broadly the same effect as that produced by a lithographic crayon on stone. The drawing is considerably larger than the finished print, so that I have more freedom and ease of execution.

Finally the subject is ready to be redrawn in pencil, in outline only, exactly the size of the print to be, traced onto the stone, and strengthened with a hard pencil. These lines will not print; they serve only as a guide for subsequent work with the lithographic crayon.

There are, of course, many ways of working on the stone. All my lithographs have been done entirely with crayon; I never use tusche washes, scraped tones, wiped tones, and so forth. This is purely a personal preference. I use Korn lithograph crayons in the pencil form, Nos. 1, 2, and 4; the softer ones (Nos. 1 and 2) are used for the darker tones and black areas; No. 4 is for light tones and fine lines.

127 *Stow Wengenroth*. Lobster Buoys. *Lithograph. Boston Public Library (Wiggin Collection)*

Whatever method is used, one should keep in mind that the superb drawing surface of the limestone affords a texture finer than any other material. It is sensitive to the subtlest gradations of line or tone, from the lightest grays to deep black, and can be worked over and over without losing freshness and bloom. As tones are re-worked and slowly darkened to the desired values, the original drawing is developed and enhanced. Textures can be kept fine or deliberately roughened up.

Occasionally a tone must be cleaned up in areas where the crayon has piled up and enlarged some of the dots that make up the tone. These can be picked out with an etching needle.

I am always conscious of the wonderful surface qualities of the stone, and this accounts for my great love of lithography. For me, a print is a work more profoundly conceived, more carefully executed, and, I hope, more successfully and richly completed than a drawing. This, I believe, should be the overriding reason for making a print—be it intaglio, relief, or planographic. The prime concern of printmaking should not be just multiplication and its economic advantages, but rather the special qualities and characteristics by which each medium can enhance the work of the artist in its own way.

PAUL WUNDERLICH
Lithography

The idea for the print *Models in the Studio* came from a photograph of nude models in my studio in Hamburg. I made the lithograph on one stone and four zinc plates in the workshop of Jacques Desjobert in Paris.

COLORPLATE 14

I began drawing with black crayon on the stone until a certain composition emerged. I then worked on the zebra-skin area with tusche and brush and spray gun, still in black. I disturbed the perfection of the sprayed tusche somewhat by scratching and with a few drops of benzine. I find working on a stone with such freedom a great pleasure.

The second color was violet, on a zinc plate. The whole background had to be filled with tusche from edge to edge—quite a laborious task!

On another zinc plate I laid in the ocher-gray area which would form the light part of the zebra skin. On the next I did the blue shading of arm, belly, and thigh with a movable stencil. On the last plate I added the tiny spot which luxuriously picks out the bright turquoise highlight in the upper left-hand corner.

The opaque violet background was printed first, a very difficult operation. Then the ocher-gray, blue, and turquoise plates were printed, in that order. Last was the black on stone. Although the black ink printed alone on damp white paper would produce many richer nuances than it does superimposed over several other colors, in this case, unfortunately, that could not be done!

I generally prefer to use Rives paper because of its whiteness. As for inks, Lorilleux Lefranc, formerly the best, have been disappointing in the last few years. Desjobert has been testing a new ink from a small firm whose name I don't remember; I have tried only the black, which proved to be excellent.

ERICH MOENCH
Lithography Techniques

In my work I prefer to use the rarer gray-blue litho stones, which are usually free

PLATE 128

128 *Erich Moench.* Small Magic Zodiac. *1967. Lithograph, 13 7/8 × 13 7/8".* Courtesy the artist

from flecks of chalk. For graining, glass-, silver-, or quartz-sand may be used, each giving an increasingly finer grain to the surface.

The tusche I use is a mixture of wax, tallow, Marseilles soap, and lampblack. Solid tusche freshly rubbed and mixed with distilled water is better than the kind already prepared in bottles.

In tracing a drawing on the stone with a stylus, care must be taken to ensure that

the tracing paper is grease-free. When the work on the stone with tusche or crayon is finished, the design is gummed and left to stand for about 6 hours.

Washes and Fine Lines

With more delicate work, such as washes and fine lines, a second gumming after inking may be necessary. The stone should be etched in separate parts, the darker areas more strongly than the lighter ones. If the design becomes too dark and closes up, it must be washed out with benzine and inked again lightly. Then it is washed with water. With a soft brush dipped in acid one can touch up the spots that seem to close up.

Washing, drying, dusting with resin and talcum, and gumming with 2 to 3 drops of etch follow in that order. Sometimes one can go quickly over the stone with a blowtorch to turn the resin and ink into a glass-hard surface. The roller should be scraped and the ink slab cleaned during printing whenever necessary. Rubber rollers should be cleaned *immediately* after use.

Generally speaking, offset inks are not stiff enough for stone lithography. A somewhat stiffer ink will have less tendency to close up the textures. Litho ink is transparent in comparison to letterpress ink. To increase this quality, transparent white or varnish is sometimes added to the ink. Opaque white should be avoided, and all inks should be used sparingly.

Various Other Techniques

For crayon work the stone should stand for several hours after the etch. If the lines appear weak, one can roll up the stone directly on the crayon work before the second etch without washing out. Again, the work should be burned in if necessary.

Rubbing tusche is used for soft shadings and is best put on with a piece of chamois or nylon. For spattering I use a metal sieve with a handle, a toothbrush, and very thick tusche. Blank areas are masked out with gum arabic, tinted with black tempera for better visibility. The gum must be allowed to dry thoroughly. It is advisable to test spattering first on a piece of paper.

White chalk can be used for drawing directly on the stone. A piece of inked paper is placed on the stone face down and pulled through the press. After the paper is removed, the stone is dusted and gummed, washed off after 5 hours, the ink removed with turpentine, and the image etched several times as above. This method produces an interesting chalklike white-line design.

Nature Structures and Other Textures

PLATES 129-135

The stone is inked thoroughly and the margins marked off with gum. Dry plants and other textured objects such as fabric or string are arranged on the stone and covered with a piece of strong white cardboard, with several sheets of newsprint on top. A piece of composition board is laid on the newsprint and over this a thin, greased metal sheet. Now the stone is pulled through the press several times, first under light pressure, which is gradually increased. The objects leave an impression on the dark surface. They are carefully removed after being gummed and allowed to stand for an hour. Then the stone is washed out with turpentine and inked with a heavy ink. Corrections can be made with litho tusche. The work should be inked and etched several times, after an interval of 5 to 6 hours each time. The textures will appear almost as photographic negatives and should be delicate but very sharp and clear.

129

130

129 - 135 *Test lithographic proofs, various textures.*
Collection Erich Moench, Tübingen, Germany

129 *Crumpled aluminum foil pressed onto inked stone, run*
through the press, and then removed

130 *Gauze*

131 *Plants*

132 *Wood inked and transferred to stone*

133 *Feathers*

134 *Wood pressed onto inked stone*

135 *Tusche on transfer paper*

131

132

133

134

135

Ball-point pens, which contain a greasy substance, can also be used to create an image. The stone is first washed with turpentine and the drawing made on the clean stone. It is dusted, gummed, and left standing for 6 hours, after which it is washed off. Now the stone is inked, dusted, etched, and again allowed to stand for 6 hours. After the third etch the stone is ready to be printed.

Transfer Technique

PLATE 136

Home-made transfer papers may be preferable to commercial ones. Any kind of textured paper can be used, if dampened slightly and stretched tightly with tape on a board. Ordinary laundry starch, boiled for 5 minutes until it has the consistency of thin pudding, is spread with a brush or sponge on the paper in a thin layer. The paper must then be dried and kept free of dust. Transfer paper can also be made with a fine coating of Chinese white tempera. On this paper one can use crayon, pen, brush, and washes. The lines or textures should not be overloaded with crayon, because they might squash on the stone during transfer. The stone should be dry and slightly warm. The pressure of the scraper should be very light, and the tympan must be well greased. The drawing is dampened and placed on the stone with four or five sheets of dampened newsprint over it (damp but not wet). It is pulled through the press several times, and the paper is remoistened with a sponge. Then, under somewhat increased pressure, the stone is pulled through again. Remoistening and increasing the pressure are continued. If the pressure is too strong, the paper will tear. The drawing is then soaked with water for about 4 minutes. After the water is mopped off, the corners of the paper may be lifted to check the transfer. If it is satisfactory, the paper is pulled off and the stone dried with a fan. In a few minutes it can be dusted with talcum, gummed, and left to stand for 6 hours. Then the gum is washed off, and the stone is sponged with water, inked sparingly, and given two or three etches.

GERTRUD J. DECH
Notes on Lithography

PLATE 137

Stone etching resembles technically the process of etching on metal (zinc or copper) but differs from stone engraving in that the line is not incised into the stone but stays on its surface as in any other lithographic process. After the stone is grained finally and is thoroughly dry, a thin coat of fresh gum arabic (old gum etches more strongly) is applied with a brush. The thin solution of gum arabic is mixed with black or red tempera color to make drawing easier. As soon as the stone is dry, the image can be drawn on it with an etching needle. Printing ink is rubbed strongly into the open lines with a piece of cloth. The stone is washed under a strong jet of water, which dissolves the gum arabic and leaves the inked lines on the stone.

One can experiment with interesting textures by interrupting the washing, with some of the ink still clinging partly to the stone and partly to the gum around the lines, so that new, delicate tone structures are formed. After washing, which may take half an hour, the stone is dried. The grease settles on the stone. It is dusted with resin, burned in with a blowtorch, and gummed. The burning and gumming are repeated after 12 hours. The ink and resin melt together and harden to give the surface the same stability as tusche.

Only now can the stone be etched, gummed, washed, and printed in the usual

136 *Erich Moench.* The Moon. *1969. Photolithograph, 17 1/2 × 11". Courtesy the artist*

137 *Gertrud J. Dech.* The Hunter from Kurpfalz. *1968. Stone etching, 15 × 13". Courtesy the artist*

way. Dampened paper is recommended. Stone etching is easy to print and resembles in character a zinc or copper etching without the tone.

Sludge Patterns on Stone
The lithographer who fully understands the characteristics of the litho stone and is interested in its creative possibilities may be confronted during the graining with an

interesting natural phenomenon that can be utilized for expressive purposes. Between the two stones rotating against each other, wave patterns are formed in the creamy sludge of grit and water. These patterns can often be preserved by a quick lifting of the top stone. One can easily work additional lines and patterns into the wet sludge or remove certain parts of it with fingers, wooden sticks, or similar means. After a thorough drying of the gritty surface, a piece of strong cardboard is rolled up with printing ink, placed face down on the stone, and run through the press under strong pressure. The stone accepts the ink wherever the dried sludge does not cover its surface, and the pattern emerges white on black. After the proper gumming, the sludge is removed with a thorough washing. The rest of the procedure follows the steps of burning in, etching, and gumming, as described above for stone etching.

Drawing on Stone with Asphalt

The method of drawing on the litho stone with asphalt does not involve the traditional chemical reactions of fat, water, and acid usually associated with stone lithography. The stone in this case will be affected by the acid only on the blank, untouched areas, and the asphalt itself will serve as the receiver of the printing ink. Instead of litho tusche, asphalt lacquer (thin or undiluted) is used on the freshly grained stone and can be manipulated with pen, brush, fingers, or wooden sticks, creating interesting relief effects. The design completed, the asphalt is left to dry, burned in strongly, and etched.

The stone can now be printed immediately, instead of waiting the usual period after the gumming. The burning melts the asphalt, and the drying afterward creates the most unusual structural patterns. The asphalt lacquer accepts the printing ink and, in addition, imparts to it a delicate brown tint, which may be compared in brilliance to the glaze of ceramics. It is very important to observe that although the stone is wet during the inking, it must be completely dry during the printing, and the paper must be dry and well sized.

FEDERICO CASTELLON
Lithographic Lifting Technique

In my own work I have favored the technique of lifting lights out of solid blacks. In *The Traveler* I used primarily washes of tusche. The first wash, which covers the entire image area including buildings and mermaid, was very light in tone but heavy with water. If such a wash is allowed to dry thoroughly, the texture becomes crinkly, and, for this print, it seemed too obvious and superficial. I therefore allowed the grays to settle slowly by letting the wash evaporate for about half an hour, and before any portion had dried I applied another wash, this time quite a bit darker but still as liquid. This time I had to allow the wash to evaporate for a good forty-five minutes— to the point of being just damp. I then laid down the third and last wash, about half as wet as the second and almost black, and let the stone dry thoroughly.

Next I totally blackened the area that was to become the mermaid. While that area dried, I worked in the darker washes at the base—the cities—and finally returned to the mermaid, which I was going to "lift."

In this technique you work the lights or lighter areas into a completely black surface. If the area is black, water is used; if the tone is less than black or the black too stubborn, gasoline can be used. However, the gasoline wash is sometimes too

PLATE 138

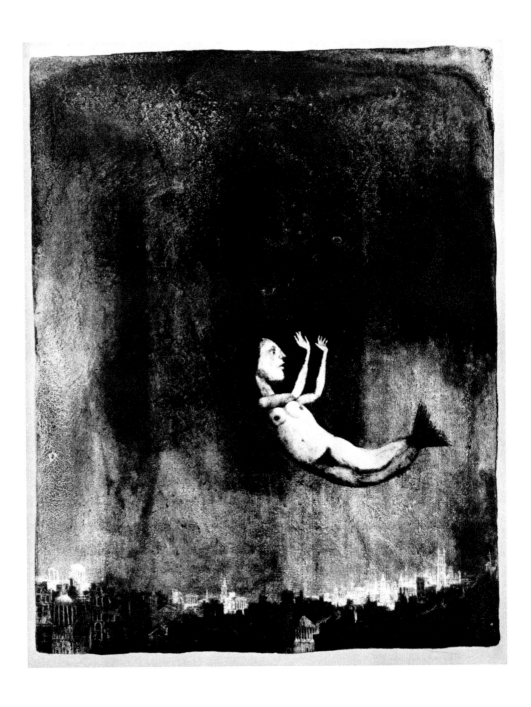

slick and lacking in character. In order to make the city less real and solid-looking, I used gasoline to lighten some of the buildings to give them the appearance of being an extension of the sky. The mermaid is floating in the sky, lost in the immensity of the world, symbolizing the loneliness of all travelers.

Perhaps the most important step in this process is to select the proper stone. The extremely hard blue stones and the soft yellow stones are almost useless for this technique. Both seem to hold the black wash against all attempts to lift it. Sometimes the tusche clings so relentlessly that any further attempts to remove it seem to fix it to the stone even more. I have had the most success with white or grayish stones, but even these have presented problems at times.

The first tusche wash should be as close to black as possible. If the primary wash is a middle gray or lighter, it seems to remain fixed, when dry, and though a subsequent black wash will lift, it will usually expose only the first immovable wash. Even if one has been fortunate enough to lay what seems to be a totally black first wash, it is safest to give the stone a second wash of very dark gray.

138 Federico Castellon. The Traveler. Lithograph. Philadelphia Museum of Art

Sometimes mixing water into the tusche results in a foam with extremely fine bubbles, which seem to disappear with the drying of the wash. In reality, minute pinpoints have resulted, and, when the stone is etched, they attract small concentrations of etch and eventually appear in the printing as large snowflakes.

Once the black wash is ready to work, one should bear in mind that the longer it stays on the stone, the harder it is to lift. However, if the stone is to be finished in about two days, there should be no difficulty.

In lightening the black to achieve all variations of tone from white to deep grays, experience will be the best teacher.

Individual areas should be lifted in one action; otherwise, two distinct sections with an irremovable seam between them will be created. For this reason a soft sable brush large enough to hold the water necessary to lift a certain area should be used. If a change of value is desired, one begins with the brush full of clear water in the part of the area designed to be the lightest. The tusche will dissolve easily and allow the eventual exposure of the stone. As the brush is worked over darker parts of the area, it will thicken with tusche until finally the dissolving process ceases.

If the earlier part of the lifting has tended to dry a bit, one should rewet it with fresh water and dab the area with facial tissue to lift the dissolved tusche. After removing the tissue, one may find that details need further drying. For this a wad of tissue is used as a blotting dabber.

For stark white highlights in already lifted areas gasoline can be used to further dissolve the tusche. Gasoline should be handled carefully, and, because of its volatility, one must work with speed. If minute spaces need lightening, one can use a razor blade or ink eraser.

To darken a large space a wad of tissue containing wash can be used to retain the texture of the print. Sometimes after lifting some areas will be heavily spotted or the entire space will seem too deep. It is wiser not to correct this until several trial proofs have been pulled. The stone often has a tendency to darken in certain areas or to build up tones where none existed, because even though the blacks have been removed, a residue of grease remains. After a few proofs this residue may have reached its limit, and one can then make final decisions on tones. If the entire surface has darkened, a sponge full of table wine washed over the inked stone will often be enough to lighten it; if stronger lightening is needed, a few drops of etch can be added to the wine. It may be necessary to repeat this procedure after each of the next few proofs. This lightening mixture should always be cleaned off with a sponge full of clear water soon after it is applied.

CHRISTIAN KRUCK
"Stone-painting" Lithography Technique

COLORPLATE 15

I developed my painting on stone as a very personal art expression, specifically a painterly one. Through experimentation with different materials as substitutes for tusche I found a lacquer that could be easily manipulated and at the same time was very acid-resistant. It is an acetone-shellac-alcohol solution which produces, depending on its rate of dilution with alcohol, light or dark values just as in conventional tusche lithography. For better visibility aniline dye is added to the lacquer.

I always print a complete edition of one color before proceeding to the next one on the same stone.

Of course this precludes the possibility of pulling an artist's proof, since the edition has to be printed in its entirety as it was planned beforehand. The size of the edition can vary; I generally keep my editions to about fifteen, to reach a little faster the end result of my stone painting. For art societies and publishers I have often pulled editions of 100 to 200 prints, and they always came out with the same sustained quality. The technique can also be used with a power press for even larger editions at an experienced establishment such as Mourlot's in Paris.

The stone can easily be changed and corrected in the press; this makes the work more enjoyable, since one is in a position to complete an edition of 200 in many colors in two or three days.

A prerequisite of this technique is an absolutely accurate knowledge of materials and color combinations. I use a soft stone of yellow color, which is slightly grained to give the lacquer a better grip on the surface. I do my rendering on the stone with ordinary writing ink, which penetrates the stone and remains visible even after correction with an abrasive but does not print.

Afterward the ink is washed off, and the stone is counter-etched for about one minute with a 5 percent vinegar solution. After the stone is dry, I paint with lacquer, either undiluted or thinned down with alcohol. Since I usually start with the brightest color, I underpaint everything that is compatible with that color. I print this color, then work over the image with snakestone, brushes, knives, and so forth. In order to make changes and additions the stone has to be opened up again by counter-etching.

The lacquer can be dissolved in alcohol to change its density and can be manipulated like litho tusche. Water, ether, or benzine may be added to it to produce different textures. Additional variations of texture can be created with soft metal brushes.

If burned in after completion, the image assumes a different structure from that produced by allowing it to dry slowly. After drying, it is further burned in with a blowtorch and then etched with a very strong gum solution. It is imperative that after any correction or addition to the drawing burning in must be repeated. Then the stone is treated as usual—washed out, rolled up, and printed.

After one color has been printed, the stone is washed out so that the design remains visible but does not accept ink. Then the second color is drawn on the stone and printed over the first. And so on until the edition is completed.

JOHN ROCK
Xylene Transfers in Lithography

The xylene transfer has been a useful extension of printmaking techniques on the lithographic stone. Commercial xylene (xylol), a mixture of isomeric colorless hydrocarbons found in coal, wood tar, and certain kinds of petroleum, is used as a solvent to transfer reproductions from printed materials to the stone.

One of the materials xylene readily dissolves is offset ink. Limiting factors that will affect the transfer are the presence of driers in the ink, the kind of paper the images were printed on, the age of the ink, and the methods used to effect the transfer. The best results are obtained from sources that were printed by offset on coated stock with no driers in the ink.

Better control is maintained if the material to be transferred is placed face down

on the stone with a thin, dense paper mat between it and the stone, to limit the size and shape of the image. These materials can be taped lightly in position so that they will not move but can be lifted slightly to observe progress. With two small pads of cotton, one dry and one soaked with xylene, the transfer is made. By alternately rubbing the back of the image with the two cotton pads, the xylene is carefully forced through the paper, loosening the ink from its supporting paper and applying it to the stone. Obviously, too much xylene will make the ink run or smear. Also, a damp stone will impair the quality of the transfer; therefore, any stone that has been stored in a room without humidity control must be dried.

139 Maltby Sykes. Galaxy. 1967. Lithograph from trimetal plate, 21 3/4 × 15 5/8". Courtesy the artist

140 *Maltby Sykes.* Moon-Viewing House. *1967. Lithograph from bimetal plate, 29 3/8 × 20". Courtesy the artist*

Burnishing devices other than cotton include pencils, fingernails, coins, and spoons, but these tend to stretch or warp the paper, making it more difficult to apply additional xylene and continue rubbing. With patience and care, however, a good sharp transfer is the result.

After the xylene evaporates from the stone and the ink is dry, drawing can be added to the stone if desired. Etching and proofing of the stone must be done carefully, and the method must be consistent with the type of work on the stone. For light images it may be advisable to delay etching the stone for several hours to ensure a better fix of the image to the stone. The etch must suit the drawing, and in proofing one must decide whether it is best to roll up or rub up the image; this can be determined with experience.

The entire procedure lends itself to interesting possibilities and variations. Some of my students have achieved impressive results by combining the xylene transfer with photoengraved cuts from local newspapers and by drawing directly on the stone.

MALTBY SYKES
Multimetal Lithography

Multimetal plates differ from single-metal plates in that they consist of two or more layers of metal, one of which is receptive to grease and another to water. Some metals, such as copper, have a natural affinity for grease. Others, such as aluminum or

PLATES 139, 140

stainless steel, have a greater affinity for water. If a printing image, which is to hold the ink, is put on the copper layer in the form of an acid resist, it protects the copper during the subsequent etching process. Unwanted copper is etched away, exposing the aluminum or stainless steel. Either aluminum or stainless steel is easily made receptive to water, establishing a nonprinting area. In printing, the copper image accepts ink and prints, while the aluminum or stainless steel accepts water and rejects ink.

Trimetal plates work by the same principle. Chromium, the top metal, accepts water more easily than grease. For this reason, it is used to form the nonprinting areas. The printing image is etched through the chromium to expose the copper, which will accept printing ink, and the image is therefore tonally reversed or negative. The base metal is simply a support and plays no part in forming the printing image unless one cuts through the copper layer in the engraving process described later.

PLATE 141

The plates most commonly marketed in the United States fall into two basic categories: bimetal plates composed of stainless steel plated with copper or of aluminum plated with copper; and trimetal plates of stainless steel plated with copper and chromium, or mild steel plated with copper and chromium, or aluminum plated with copper and chromium.

Multimetal plates are generally available in thicknesses ranging from .012 to .025, though small plates may be of a lighter gauge. For large plates, heavier gauges are easier to manipulate. However, light gauges have certain advantages. They may be cut with shears or other instruments for metal collage, embossing, or special effects. Also, they are cheaper.

The artist may create his image on multimetal plates with any acid-resisting material. Lithographic crayons, tusche, rubbing ink, wax crayons, and grease pencils all work well. So do spray enamels or lacquers, asphaltum, powdered rosin, and all acid resists used in intaglio printmaking. Trimetal plates on a mild-steel base may be engraved with a burin or diamond point, and half tones may be obtained with the roulette, carborundum grit, snakestones, or any abrasive.

The advantage of multimetal plates lies in the fact that the image and nonimage areas are permanently fixed in grease-receptive and water-receptive metals. The image will not fill in or become blind if properly processed. If scum develops, it is easily removed without disturbing the image. If copper refuses to take ink, it may be made to do so by simple methods. Deletions are simple for multimetal plates; additions are more complicated but possible. Manufacturers furnish instructions for replating local areas on a plate.

Processing Multimetal Plates

Manufacturers supply processing instructions for their plates, and these should be consulted whenever possible. The proprietary processing materials marketed by manufacturers for their plates should also be employed for best results. However, these processing instructions are for photomechanical platemaking, and must be interpreted by the artist-lithographer to meet his needs.

The steps in the procedure are as follows: first, cleaning and counter-etching; second, creating the image; third, etching to establish image and nonimage areas for

141 Multimetal plates

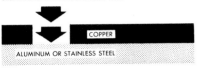

BIMETAL PLATES: Copper is top metal and forms printing image. Copper etch eats away unwanted copper to expose non-printing base metal of aluminum or stainless steel.

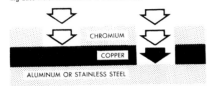

TRIMETAL PLATES, ETCHED: Chromium is top metal and forms non printing surface. Chromium etch eats away unwanted chromium to expose copper for printing image. Corrections may be made by etching through unwanted copper to expose non-printing base metal of aluminum or stainless steel.

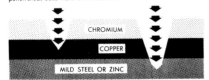

TRIMETAL PLATES, ENGRAVED: Base metal must be mild steel or zinc, both of which accept ink. Engraving tools cut through chromium to expose copper printing image. If copper layer is penetrated, base metal still holds ink.

printing; fourth, washing out and rubbing up; fifth, desensitizing and gumming; sixth, rolling up; and finally, printing.

Cleaning and Counter-etching

The plate is placed in an acid tray or sink and rinsed with water. It should be scrubbed lightly with a soft bristle (not nylon) brush, rag, or paper wipe to remove the protective gum coating applied by the manufacturer. Then the plate is flushed with the appropriate counter-etch solution and allowed to stand for 30 seconds.

Counter-etching both cleans and sensitizes the plate, making it receptive to grease, water, or gum, depending on which is applied first. Counter-etches actually dissolve some of the metal forming the plate surface, and, if left too long on the plate, will eat away some of the grain; a period of 30 to 60 seconds is usually enough.

Suggested formulas for counter-etches are: For aluminum-base bimetal plates, 2 ounces nitric acid to one gallon of water. For stainless-steel-base bimetal plates, 2 ounces nitric acid and 2 ounces phosphoric acid to one gallon of water, or 2 1/2 ounces sulfuric acid to one gallon of water. For trimetal plates having a base of stainless steel, mild steel, or aluminum, 2 1/2 ounces sulfuric acid to one gallon of water.

Stubborn spots of grease or oxidation are rubbed with FFF pumice. Finally the plate is rinsed with water and fanned dry.

Creating the Image

The image may be drawn, painted, transferred, or otherwise produced, but it must be done directly after the cleaning process. If the plate is allowed to stand before using, it will oxidize and have to be counter-etched again. The acid-resisting image will print as a positive from bimetal plates and as a negative from trimetal plates. To engrave trimetal plates, simply clean the plate surface, cut through the chromium with engraving tools or abrasives to expose the copper, rub up the image, and print.

If tusche or spray paints have been used, they must be allowed to dry or set.

An optional procedure is to shake a half-and-half mixture of rosin powder and talc over the image and remove the excess with a dust brush.

Etching for Image and Nonimage Areas

The term "etch" is a misnomer in stone or single-metal lithography, since the litho etch desensitizes, rather than eats away, the surface of the plate or stone.

In multimetal lithography both the desensitizing etch and the true etch are employed. For example, with a bimetal plate, unwanted copper is actually etched away with acid to expose the nonimage area. Then the exposed nonimage area is given a plate etch to desensitize it as completely as possible and increase the hydrophilic nature of the metal.

First the plate is covered quickly and evenly with etch. To move the etch over the surface the tray is rocked or the plate manipulated. A developing pad is convenient but not essential.

With bimetal plates, the base metal will begin to show through the copper within a minute or a minute and a half, usually about 80 seconds. When this occurs, the plate is removed from the etch and rinsed with water. The old etch is poured off and fresh etch applied. The base metal should become clear of copper quickly (usually

from 20 to 30 seconds), forming the nonimage area. Etching may be repeated, if necessary, followed again by thorough rinsing with water.

With trimetal plates, the copper will appear through the chromium. As chromium dissolves, it will form bubbles and then discolor. Copper will begin to show through the chromium in 50 to 80 seconds, depending on the type of plate. When this occurs, the plate is removed from the etch, rinsed with water, and inspected. The old etch is then poured off and fresh etch applied to the plate. The copper should clear in about 30 seconds. The plate is removed from the etch immediately and again rinsed with water.

Proprietary etches are provided by manufacturers under several trade names. The usual etches for bimetal aluminum plates are basically ferric nitrate, whereas etches for stainless-steel bimetal plates generally contain ferric chloride. Neither of these two etches has particularly objectionable fumes. When used on the plates for which they are intended, they remove only copper and do not attack the base metal.

Most etches for chromium contain hydrochloric acid, and very irritating fumes are produced. Down-draft ventilation or a respirator with acid filter is required in using these etches. The chromium etch manufactured by Printing Developments Incorporated is nonfuming and may be used without special ventilation. Chromium etches do not attack copper or the base metal, and copper etches do not attack chromium.

Many mordants prepared by the artist for etching copper intaglio plates may be used for bimetal plates. The following are examples: For etching aluminum-base bimetal plates, 1 part nitric acid to 3 parts water may be used, or, if desired, a stronger or weaker solution. To activate the etch, a little old etch may be added or a penny may be left in the etch until it takes on a bluish color. An alternative mixture is a 47-degree Baumé solution of ferric nitrate. To decrease the speed of the etch water may be added.

For etching stainless-steel-base bimetal plates, nitric acid is used in the same way as for bimetal plates, or a 43-degree Baumé solution of ferric chloride, with water added to slow the speed of the etch, as described above. A third mixture suitable for these plates is Dutch mordant (1 ounce of potassium chlorate in 27 ounces of very hot water with 5 ounces of hydrochloric acid). To increase the speed of the etch the proportion of water may be decreased.

Neither Dutch mordant nor the ferric chloride solution is suitable for etching aluminum-base bimetal plates.

For trimetal plates (either aluminum-base or stainless-steel-base), the following nonfuming etch is recommended by the Graphic Arts Technical Foundation (formerly Lithographic Technical Foundation) in *LTF Research Progress,* No. 17: 3 quarts aluminum chloride solution, 32-degree Baumé; 5 1/2 pounds granular, technical-grade zinc chloride; and 5 ounces 85 percent phosphoric acid. The zinc chloride is dissolved in the aluminum chloride solution. The resulting solution should have a Baumé of at least 55 degrees. If the Baumé is higher than 55 degrees, the solution must not be diluted with water. If the Baumé is lower than 55 degrees, more zinc chloride is added to bring it up to 55 degrees and then the phosphoric acid is added. Total volume of the finished solution is about one gallon.

If any difficulty is experienced in obtaining the aluminum chloride solution or granular, technical-grade zinc chloride from local supply houses, they may be

obtained from any of the following: Grasselli Chemical Division of the E. I. duPont de Nemours Co., Wilmington, Del.; General Chemical Corporation, 205 S. 16th St., Milwaukee, Wisc.; or Mallinckrodt Chemical Works, 2d and Mallinckrodt Sts., St. Louis, Mo.

Washing Out and Rubbing Up

First the plate is flooded with counter-etch solution. It is kept wet with the solution while the acid-resisting image is washed out with turpentine or other appropriate solvent. Then it is flushed clean with water.

When the copper image area has been made ready for inking, the image is "rubbed up" with an ink prepared for that purpose. This is accomplished with two rags, one wet with the counter-etch solution and another with rub-up ink. With one rag an area is dampened with the counter-etch solution, and the other rag is charged with a small amount of rub-up ink. It is better to put a drop or two of turpentine on the ink rag prior to inking it. While the area to be inked is still damp, the ink rag is rubbed over it with a circular motion. The dampened nonimage area will reject ink, while the copper image area will accept it. If the copper does not take ink well, it is rubbed with dilute phosphoric acid (8 ounces of 85 percent phosphoric acid to a gallon of water) or dilute sulfuric acid (2 1/2 ounces to a gallon of water) and a little fine pumice. There are also preparations made by most manufacturers to activate the copper. If the nonprinting area takes ink, rubbing with counter-etch solution and pumice should clean it.

The process of dampening and rubbing up small areas is continued until the entire image is inked.

Desensitizing Etch and Gumming

This step is carried out immediately following the preceding one. A plate etch consisting of 1 ounce of 85 percent phosphoric acid to 32 ounces of 10-degree Baumé gum-arabic solution is applied with a brush or viscose sponge. Gradually the etch is smoothed out with a dry rag or paper wipe and rubbed to a thin, dry film. This also serves as final gumming.

The plate may now be either stored or printed. The rub-up ink is washed out of the image with asphaltum and the plate rubbed dry. If the plate is to be stored, it should be left under asphaltum. If printing is to proceed, the dried etch is sponged off with water, the plate is rolled up with printing ink, and the process goes forward.

Printing

Multimetal plates can be printed under felts on an etching press, as in intaglio printing. Best results are obtained by soaking the paper.

To print multimetal plates under the scraper on a lithographic press, a lithographic stone slightly larger than the plate itself is needed as a support. The back of the plate and the surface of the stone are both dampened. When the plate is placed on the stone, it will adhere firmly. Printing then proceeds in the usual manner.

[NOTE: Adapted with permission from Maltby Sykes, copyright © 1969, and Pratt Institute, Brooklyn, N. Y., copyright © 1968.]

COLORPLATE 16

REGINALD NEAL

Notes on the Photolitho Process

3M(R) Presensitized Aluminum Plates

3M presensitized aluminum plates come from the manufacturer coated on both sides with a light-sensitive emulsion. Therefore, *plates must be protected from light and moisture,* because light hardens the emulsion, making it receptive to ink, and moisture destroys the emulsion.

For working directly on the plates, the work light must not be stronger than a 25-watt incandescent bulb. Natural daylight and fluorescent lights are too strong. The emulsion on plates is very slow and requires strong photo flood or arc light for exposure, but, even so, long exposure to any light will eventually affect the emulsion.

Drawings can be made directly on the plate with any material that will adhere to the smooth surface and at the same time prevent light from reaching the emulsion underneath the drawing. Soft litho crayon, tusche, or photographer's red opaque paint work well. Opaque materials such as black paper stencils or small flat objects (coins, washers, etc.) can be laid on the plate. When objects of different thicknesses are used to block out light, exposure cannot be made in the vacuum table. Instead, a photo flood No. 2 bulb in reflector is held 18 inches above the plate for an exposure of 5 to 8 minutes. The direct method will produce essentially black-and-white images (no half tones). Exposure must be made long enough to produce solid blacks and whites. *Cutting down on exposure to obtain gray areas is not satisfactory.*

Removing the emulsion locally by scraping or by the use of a solvent will produce a white printed area. Thus, a white-line drawing can be obtained by scratching through the emulsion with an etching needle or other sharp tool. Larger areas of emulsion can be removed by the use of an abrasive such as a "scotch hone" or emery paper. When working directly on presensitized plates, it is essential to work as rapidly as possible in a subdued light. The surface of the plate must never be touched with the hand, for grease and moisture from the skin will damage the emulsion.

Handmade negatives for black-line drawings may be prepared as follows: A piece of clear (or frosted) acetate is coated with black acrylic paint, brushed or rolled on in several coats until no light can penetrate and allowed to dry thoroughly. Then, with sharp tools (razor blades, etching needles, dental tools, or knives) the paint is removed, exposing the acetate. If large white areas are desired, paint may be removed with solvent.

A large selection of textures and half-tone effects can be created by the use of Zip-a-Tone papers to break up the pattern of exposure on the emulsion. These may be used directly on the metal plate or incorporated in the handmade negatives if a pattern is desired instead of a black line.

Photo negatives (as opposed to handmade negatives) offer greater possibilities. These can be made from original line drawings, from printed half-tone material, or from the incorporation of Zip-a-Tone in the original art work. The finished art work (usually on illustration board) is made into a line negative, which is then placed in the vacuum table for exposure on the 3M plate.

A full range of values (from subtle grays to solid blacks) can be achieved by employing the photo screen method. This requires that the original art work be photographed through a screen, which breaks up the image into minute dots. The

screens are referred to by the number of lines per square inch: 60-line, 100-line, 150-line, on up to 300 or more lines. The greater the number of lines, the greater detail. Half-tone negatives may be incorporated with any of the previously described methods or used for the entire image on the presensitized plates.

ST Grained Aluminum Plates
The coating solution is prepared by adding all of the ST Super-D powder to the ST base solution. The liquid must be shaken vigorously until the powder is dissolved. In this form, the solution will keep for one week at normal room temperature.

ST plates are ready for use and do not require any treatment prior to coating. Care should be exercised in handling the plates to avoid smudges or fingerprints that may reproduce. The plate is placed on a table, over waste sheets somewhat larger than the plate itself. A small amount of ST coating is poured on the plate and spread evenly with ST wipes. Other wipes may leave lint, which can cause pinholes or otherwise damage the work area. The wiping strokes are alternated first from side to side, then up and down, to obtain a uniform, smooth coating. The plate is then dried thoroughly with fresh ST wipes. The operation must be performed in subdued light (yellow or gold fluorescent lights are recommended), and plates should be coated, exposed, and finished the same day.

Exposure of the ST plate is done in the usual manner. A Solid Step 6 on the L.T.F. exposure guide will provide a satisfactory print.

The Super-D developer must be shaken well before use. A sufficient amount is poured onto the plate and worked over the entire plate area with a damp sponge. When the plate is completely developed, the image will have an intense color. Excess developer is then rinsed off, and the cleaning operation is completed with a cotton swab under running water.

Excess water must be drained by tilting the plate (not squeegeed). Following this, Super-D A.G.E. is poured on the wet plate and, with a damp cellulose sponge, rubbed over the entire plate, with special attention to the image area. This operation will give an extremely water-repellent surface to the image area. The A.G.E. is not rinsed off the plate when it is taken out of the sink.

The final step is to add a little Super-D gum etch, spread it around with a damp cheesecloth, and dry with a soft cloth, as if the gum etch were a gum-arabic solution.

MISCH KOHN
Photolithography
The photographic method in both stone and metal-plate lithography is a useful addition to the hand-drawn processes and may be used along with them. However, the photo elements should be put on the stone or plate first.

The four chemicals used are the standard ones prepared for aluminum-plate lithography: sensitizing solution, powdered sensitizer, red lacquer developing solution, and A.G.E. solution (asphaltum gum etch).

Steps in the procedure are as follows:

The stone is ground as usual. (The finer the grain, the closer the texture of the image.)

In a small container such as a baby-food jar 1 ounce of sensitizing solution is mixed well with 1/4 teaspoon of sensitizing powder. The concentration should stain

an intense yellow. This mixture will not keep and must be prepared fresh each day.

A part of the solution is poured on the stone and spread with a small piece of sponge to cover it at once. It must be wiped thin and without streaks, and then allowed to dry. (As the solution is spread thin, it dries in about a minute.) Lint particles should be dusted off. The stone will be stained yellow; it is now light-sensitive but reacts very slowly; it can be left uncovered for several minutes without being affected.

The photographic negative is laid, emulsion side down, on the plate or stone. This has to be a high-contrast Kodalith negative or a negative with a half-tone screen built into it. A continuous-tone negative will not work. Instead of the photo negative, a drawing in ink or soft pencil on tracing paper or acetate plus Zip-a-Tone dot-and-line screens may be used to form a collage image.

The borders are blocked off with aluminum foil, and a glass plate is pressed down on top of the negative with care to ensure a good contact.

A light source is necessary to expose the stone; the best is an arc lamp. However, it is possible to use a mercury-vapor sun lamp or photo floodlights; even sunlight will do, but it takes much longer. The light source should be suspended 18 to 24 inches above the stone. The exposed bright yellow of the stone will have dulled somewhat after 5 minutes; to check this the light must be removed. The color will appear as a grayed orangish green, depending on the natural hue of the stone. If the change in color is not very apparent, another 3 to 5 minutes should complete the exposure. It is difficult to overexpose a stone.

After sufficient exposure the stone is placed on the sink, and a wipe-on developer is applied. The bottle should be shaken well before use. A small pool about 5 inches across on the stone should be adequate to cover the entire image. It is then wiped with a small piece of clean sponge, worked back and forth with smooth, even strokes. The developer will begin to stick to the image; as wiping pressure is increased, the image will pick up more and more lacquer. The image should be a solid red at all points when fully developed.

The stone is then rinsed well with cold water and allowed to dry. All excess red developing lacquer should be rinsed off.

A bottle of A.G.E. should be shaken vigorously and a few ounces poured on the stone. With a clean sponge the image part of the stone is covered and rubbed fairly hard. Then the A.G.E. is wiped thin and left to dry like a normal gum etch. (The A.G.E. contains a mild gum etch and asphaltum, leaving a greasy deposit and making the image receptive to ink.)

After the stone has thoroughly dried, it is again rinsed with water, wiped with a sponge, and rolled up as if it were a drawn image. The lacquer stays on the stone throughout printing. The stone may be resensitized with acetic acid, and further drawing can be done around, within, or over the photographic image.

Etching is done in the normal manner for stone (10 drops of nitric acid plus 3 drops of phosphoric acid in 1 ounce of gum). If part of the photo image is not wanted, it can be scratched away with a knife edge or pumice stick before the etch.

JAMES LANIER
Photosensitizing Metal and Paper Plates

PLATES 142-143 *Photographic Litho Plates*
There are many different types of metal plates available to the artist. It has been my

143

142

142 Robert Rauschenberg. Kiesler. 1966.
 Color offset lithograph, 33 15/16 × 22".
 Museum of Modern Art, New York
 (John B. Turner Fund)
143 Allen Jones. She's Real, He's Real. 1964.
 Color offset lithograph. Philadelphia
 Museum of Art

experience that the presensitized plate offers the best all-round service with the greatest dependability. The stability of presensitized plates, together with the elimination of the several chemicals necessary for sensitizing, makes them well worth the additional cost. Many different presensitized plates are available in the United States. My own choice has been the 3M brand S plates. They are very easily worked and long-lived. Only two chemicals are needed to develop and gum them.

Whatever the choice, the manufacturer's recommendations, included in each package of plates, should be followed.

Such plates may be printed either on an offset press or on a stone litho press. The offset press derives its ink impression from a rubber blanket on an intermediate cylinder. Therefore, through a double transfer, the image appearing on the plate is printed exactly as it shows there. If the plate is printed directly on a litho press, only one transfer is effected and the image is reversed.

Art work for platemaking is prepared on any transparent material and may be composed of combinations of line and half-tone copy.

Proper equipment for the making of plates is essential. The items are: a copy camera, used for making line and half-tone negatives; a vacuum frame to effect complete contact of the plate emulsion with the copy, which prevents light leakage around the edges and resulting distortion; and a light source. For this last requirement the carbon arc is the best choice, but photo flood bulbs, ultraviolet lamps, xenon lights, or daylight fluorescent tubes will give satisfactory results. If a vacuum frame is not available, a piece of glass held securely in place over plate and copy will serve reasonably well.

When printing the plate on a litho press, I use a mixture of 1 ounce of 3M brand fountain concentrate to 1 ounce of gum arabic and 1 gallon of water for dampening the plate. Offset inks give excellent results but may have to be thickened with corn starch or other materials.

Aluminum plates oxidize if not protected by gum. Plates should never stand unprotected for more than a few minutes without gumming.

Direct-image Paper Plates

Paper offset plates offer an inexpensive method of producing single- or multicolored prints. The Remington Rand Company produces a plate called Plasti-Plate that can be drawn on directly with several media. The same company makes a ball-point pen obtainable in fine, medium, and broad points. Higgins violet ink works very well for any method of application. Litho crayon and pencil can also be used, as well as thinned tusche.

The major problem in the use of paper plates is the necessity of printing them on an offset press. One must either have one available or find a printer who will print for him. The plate must be cut specifically for the press that is to print it, and the margins must be provided for on the plate.

There are available photosensitive paper plates which permit the incorporation of a photo image together with the drawing. On these the photo plate is produced first and the image is then drawn on it.

[NOTE: Adapted with permission from *Artist's Proof*]

CHAPTER 4
SILKSCREEN

History

Silkscreen is the most recent of the printmaking processes to attain the status of an art form, having suffered in the past from unfavorable association with the commercial uses of the medium. The low regard in which screen prints were held for more than a quarter of the present century is indicated by the coinage of a new name, "serigraphy," attributed to Carl Zigrosser, in order to distinguish art prints from the screen-processed images mass-produced for commerce and industry.

The basic principle of the technique was that of forcing color through the interstices of a silk fabric left open around images cut out of paper and attached to the silk, thus printing the design on a surface laid underneath. In the beginning the stencil was essentially a simple silhouetted design serving to block the passage of color to the printing surface. Later improvements included many radical changes in the basic material of both the resistant stencil and the porous mesh that supports it, as well as chemical sensitizing of the screen fabric to permit the transmission of photographic images.

The stencil process cannot be traced to any one inventor; its antecedents are lost in the remote past. In some of the earliest art periods there appears the "stenciled hand," a motif evolved by prehistoric artists who sprayed color around the spread fingers of a human hand on rock surfaces. In primitive societies stencils may also have been used to tattoo the human skin.

In the Orient stencil patterns have appeared since ancient times. Chinese cut-paper designs were used not only as an independent art form but also to transfer patterns to cloth for embroidery. In Japan the stencil method achieved notability in the Kamakura period, when samurai leather armor and horse trappings were embellished in that manner, and later, in the seventeenth and eighteenth centuries, when silks were printed through silkscreened stencils. The Japanese developed a unique solution for one of the major technical problems involved in the process—that is, how to hold together the parts of the stencil that become separated when the silhouette forms are cut out. In general this was accomplished by leaving strips of paper or "bridges" connecting the "islands" of the design, a device frequently seen in the stenciled lettering on present-day bales and crates. The Japanese held the sections of their delicately cut stencil elements in place with hair or slender silk fibers, which formed bridges so inconspicuous as to be almost invisible in the printed image.

In America, from colonial times on, furniture. tinware, fabrics, walls, and other surfaces were decorated by stencil—a technique that not only facilitated the labor of the craftsman but also permitted a system of "repeats" for allover patterns. Prized by collectors of folk art are also the "theorem paintings" (often flower and fruit motifs hand-colored through stencils on velvet), the painstaking work of schoolgirls and leisured ladies of the nineteenth century.

In England, some sign painters at the beginning of this century must have used the silkscreen method for their trade but attempted to keep their procedures a secret for many years. About 1900 the usefulness of the technique to industry had become fully apparent, and patents were taken out for specific uses in England and the United States (c. 1907 and 1915). Banners, posters, show cards, billboards, and labels were issued in vast quantities. In consequence, the medium was viewed as a commercial process for mass production. Artists and printmakers gave it a wide berth, instead of welcoming it as a new form of graphic expression, as earlier artists had embraced or revived engraving, mezzotint, and lithography. Aggravating the situation were

certain biases of established print organizations and juries, which often held the silk-screen ineligible for admission to exhibitions.

Very rarely some artists early in the century found in the stencil process a tool for creating prints that added a new idiom to their graphic vocabulary. The *Seated Cat* by Théophile Steinlen, a Swiss-born artist who lived in Paris and died in 1923, stands out as one of the finest early examples of the long-neglected silkscreen medium.

In the United States it was the Great Depression of the 1930s and the efforts of the WPA Federal Art Project that prompted a group of artists, headed by Anthony Velonis, to experiment with silkscreen for artistic purposes. In those difficult times the inexpensiveness of the equipment needed for the process offered an important economic advantage over the other print media. The materials were easily assembled, constructed, and operated without heavy investment in copper plates, presses,

PLATE 144

144 *Théophile Steinlen. Seated Cat. Early 20th century. Color stencil print, 14 × 11 1/2". Boston Public Library (Wiggin Collection)*

145

PLATE 145

stones, wood blocks, and the other paraphernalia of the relief, intaglio, or lithographic media.

At the bedrock level of expense, the nucleus of a serigraph print shop needs only the following basic materials: a wooden frame covered by a piece of fine-meshed silk tightly stretched in the manner of a canvas and attached with hinges to a baseboard; stencil paper or other masking material from which to cut out the image elements; a squeegee or similar device for squeezing the color through the silk mesh; special inks or paints; paper for printing the editions; and either a rack or the time-honored clothesline with clothespins for drying the prints. Depending on the adhesive properties of the colors used, the silkscreen process can be applied to almost any surface, including glass, metal, plastics, textiles, ceramics, and synthetics of virtually any shape and texture. Special high-quality paper is not essential, nor is the size a crucial factor, for the frame can be made in almost any dimensions to accommodate the image without great difficulty. And finally, silkscreen printing can easily produce very large editions. This fact enabled artists during the Depression to reach a wide, low-income public ready to buy inexpensive original prints.

For such reasons some American artists of distinction turned their talents in the 1930s to experimentation in the medium, among them Ben Shahn, Robert Gwath-

145 *Ben Shahn. All That Is Beautiful. 1965.
Silkscreen, 26 × 39". New Britain
Museum of American Art, New Britain,
Conn. (Stephen Lawrence Fund)*
146 *Marcel Duchamp. Self-portrait. 1959.
Color silkscreen, 7 7/8 × 7 7/8". Museum
of Modern Art, New York (gift of Lang
Charities, Inc.)*

146

mey, Harry Sternberg, and others with a social conscience, who tried to refine or redefine this commercially abused process. The traditional methods had generally presented areas of unmodulated color, faintly textured by the grid of the screen, defining forms and shapes with little subtlety. Those artists attempted to impart to this seemingly inflexible and somewhat mechanical medium some of the painterly quality of their own individual styles and, with it, their concern with the social and political issues of their time.

This kind of effort to "personalize" the silkscreen print and improve its visual quality continued to some extent with the artists of the 1950s, including the Abstract Expressionists and Action Painters, such as Jackson Pollock, who explored the medium without becoming enamored of it. Even anti-artist Marcel Duchamp, never very active as a printmaker, tried his playful hand at the serigraphic *Self-portrait* *PLATE 146* shown here.

In Germany, ironically, interest in the medium was generated as late as the end of World War II, when American airplanes landed in Cologne, their fusilages decorated with screened decals of the lusty, comic, and vainglorious emblems that proclaimed the group spirit of their crews.

Not until the late 1950s and early 1960s, however, did serigraphy develop into the generally acclaimed and accepted medium of the so-called avant-garde, producing a plethora of exhibitions and a cross-breeding with other media that breached and finally broke down long-established barriers and definitions. The responsibility for this turn of events rests largely upon the new concepts of certain popular art movements and the advancement of technology in silkscreen printing, utilizing photographic devices.

Pop art, for example, moved in with a widespread adoption of found objects and of images from the mass-communications media. Op art worked by means of concentrating on colors and shapes chosen to induce optical illusions in color and motion. The so-called "hard-edge," "stripe," "color-field," and "sign" paintings found their footing in bold and clear-cut shapes and contrasts of rather flat color; and Minimal art made use of ultrasimplified forms and almost indistinguishable modulations of color or texture. Often the aim was to obliterate the artist's personality, his individual brush stroke, the handmade touch that would single him out from the mass culture he wished to represent.

PLATE 154

The same visual qualities that were objectionable to the artists who first approached the silkscreen made it a "natural" for the "cool," impersonal product, as well as for the faithful reproduction of photograph elements from the mass media for collage purposes. In addition, the adaptability of the silkscreen to shaped, three-dimensional surfaces of depth and volume fitted conveniently into the growing tendency to confound the traditional categories and boundaries of painting, sculpture, and printmaking.

Many well-known artists identified with these movements have turned to serigraphy, among them Pop artists Robert Rauschenberg, James Rosenquist, Andy Warhol, and Roy Lichtenstein; Victor Vasarely and Richard Anuszkiewicz, conspicuous as Op exponents; and Josef Albers, the patriarch of hard-edge imagery, along with such younger men as Robert Indiana, Frank Stella, Nicholas Kruschenek, Jack Youngerman, and others.

PLATES 147, 148

COLORPLATE 17

The technical developments that went hand in hand with these approaches to art were not all entirely new. Photography, for instance, had long been used in the commercial screen process. It was the eagerness of artists to adopt more mechanical, less autographic modes of expression that brought to the fore a number of unconventional materials and procedures. One great advantage of the stencil method has always been that the image created on the screen does not have to be prepared in reverse by the artist. By sensitizing the screen and applying to it a photographic positive film, one can also develop the screen into a negative and produce a positive image on the final print. The film, of course, can be prepared from either the artist's own design or any image from other sources.

COLORPLATE 21

New substitutes for the paper stencil have been thin metal foil, heavily varnished papers, plastics, adhesive films and tapes, and masking fluids. The use of these fluids, which can be freely brushed on the screen, eliminates the rigidity of outline originally associated with the knife-cut stencil and opens the way for more spontaneous painterly effects, once so difficult to achieve in this medium.

Instead of silk for the screen, one can use stainless-steel mesh or synthetic gauze so fine that it allows considerable detail in half-tone and continuous-tone images, thus freeing the serigraph from some of its original textural limitations. Also available are thermo-electric screens, which produce a print that dries almost at the instant of contact. Many silkscreen printing plants have motorized equipment and can print several thousand impressions per hour on rotary and mechanized flat-bed presses.

With the availability of so many new tools and materials, and with the preoccupation of many artists with mass communication, it was inevitable that the former criteria of printmaking should be severely questioned. The Print Council of America, for example, had decreed that a print could be considered original only if it had been

147 *Robert Rauschenberg. Signs. 1970. Photo silkscreen, 43 × 34". Courtesy Castelli Graphics, Inc., New York*

148 Andy Warhol. Banana. 1966. Color silkscreen, 52 × 24". Courtesy Castelli Graphics, Inc., New York

prepared, produced, and executed by the artist. But for a new breed of artists the technical aspects of producing silkscreen prints were of interest only in the conceptual stage—the problems of composition and juxtaposition, choice of photographic images, color schemes, and interpretation of the source materials conveyed through size, placement, repetitions, and textural manipulations. Unskilled or uninterested in the minutiae of the technical procedure, they preferred to turn over to workshop technicians their detailed instructions, images, and color notes, and stand by for consultation or leave the execution entirely to the printing professionals. It seems that the print totally made by the hand of the artist is on the way out; in fact, it had not always been in. Even in the distant past of printmaking the great German wood-

cut artists had relied on the skill of their formcutters, as many of the great French artists of our time have depended on their master printers. Collaboration had existed throughout the centuries between artists and workshop technicians. The twentieth century has extended such teamwork even further.

Sharp controversy has greeted the use of material such as photographs and images transferred from the printed mass media. If the images were not created by the artist and no part of the print was executed by his hand, why should the result be called an original print? However, artists today may claim that their contribution is as original and valid as the assemblages, collages, environments, and *objets trouvés* that have been exhibited as art in the heyday of Dada, Surrealism, and Pop—and their point of view has found general acceptance today.

The silkscreen thus brought into sharper focus some of the disputes over standards and definitions that had been troubling the print field for some time. The signature itself gave rise to more argument. Formerly each print was supposed to be hand-signed by the artist, but if the edition runs to thousands, the handling of the signature presents serious physical problems. In such cases the artist has sometimes consented to have his name added by rubber stamp, a questionable practice which may throw the whole problem of the value of the artist's signature and of the signed and numbered print into a cocked hat.

It will take time for these new concepts in printmaking to be reconciled with traditional ideas, and much of today's output of serigraphy must still bear the stigma of its commercial past. The fact remains that serigraphs are now "in" and singled out for popular exhibitions because so many prominent painters, sculptors, and experienced printmakers, for better or for worse, have taken the medium to their hearts.

In France, Vasarely's Paris workshop has been instrumental in spreading the silkscreen process for both artistic and commercial purposes. The complex collages of Eduardo Paolozzi, an artist of Scottish and Italian ancestry, and Ronald Kitaj, an *COLORPLATE 18, PLATE 149* expatriate American, have made a considerable impression both in England and in America. Their prints have often been labeled "literary," for they frequently combine verbal matter, puns, and word allusions with diverse clippings and sometimes esoteric images from the repertory of the printed media. Both have acknowledged their indebtedness to the skill and ingenuity of the printer Christopher Prater, who has the technical abilities to bring their ideas to realization. Another Englishman, Joe Tilson, has entered into the realm of mixed media with screen-printed reliefs on a foundation of vacuum-formed plastic sheets.

Artists who prefer to work closely with landscapes and natural objects, such as Robert Burkert and, more abstractly, Steve Poleskie, have, in very different ways, adapted serigraphy to their subject matter. The figural painter and sculptor Ernest Trova has found the medium versatile enough for the many variations of his "falling *PLATE 150* man" motif. Corita Kent (Sister Mary Corita), whose subject matter is predominantly of a religious and humanitarian nature, has used silkscreen for both figural compositions, such as *The Lord Is with Thee* (illustrated in the next chapter), and for her calligraphic messages, done with the casualness of graffiti. Clayton Pond and Ken Price have made effective use of flat, brilliant colors in compositions of indoor and *COLORPLATE 19* outdoor scenes posing as still lifes.

Among the well-known printmakers who work in other media, Carol Summers, Andrew Stasik, and Misch Kohn have also worked successfully in serigraphy. *PLATE 151*

Japanese-born Norio Azuma explores both textural and structural possibilities of hard-edge color squares in endless variations of the medium.

It is interesting that the stencil process, which had its earliest roots in primitive and prehistoric art, has returned to its origins in modern programs of art teaching among Eskimos and American Indians. In recent years, under the initial guidance of Canadian artist and writer James Houston, Eskimos in their West Baffin Cooperative Workshop have produced amazingly fine prints from stencils cut out of sealskin. In the studios and workshops of the so-called "developing" countries the silkscreen, with its low production cost and increasing prestige in the Western art world, is bound to play a more and more significant role.

Obviously, not all stencil methods result in prints (or in multiples), and not all screen-processed images are made from cutout stencils. *Pochoir,* a reproductive process developed in France, makes use of stencils, with color brushed directly onto the paper. Paintings, drawings, and watercolors by such artists as Blake, Severini, Klee, Kandinsky, Rouault, and Miró have been successfully reproduced in this medium. Because of their handmade appearance, *pochoir* reproductions have been used in limited editions of books and in print portfolios, often honestly identified as reproductions and not original prints.

PLATE 152

149 *R. B. Kitaj.* Bullets, Die gute alte Zeit. *1969. Silkscreen and collage, 41 × 26 3/4". Reproduced from catalogue, Galerie Mikro, Berlin (© 1969, Michael S. Cullen)*

150 *Ernest Trova.* Four Figures on an Orange Square, *from the* Falling Man *Series. 1965. Color silkscreen, 25 1/16 × 25 1/16". Museum of Modern Art, New York (John B. Turner Fund)*

PLATE 153

Individual paintings by Robert Rauschenberg and other contemporary artists have sometimes had incorporated elements executed by silkscreen, and three-dimensional objects akin to sculpture have had color applied by silkscreen, whether or not they were produced as multiples. In recent years serigraphy has so frequently been combined with lithography, intaglio, and other media that the resulting prints, sometimes embossed with found objects and linked with electronic components, can only be appropriately described as "mixed media." This is the twilight zone of contemporary printmaking, and it will confound the experts and critics for years to come.

From the inception of printmaking one aim of the artist has been to make his work available to the art-conscious public with a slim purse. The so-called "art explosion" of recent years, with its seller's market, has somewhat negated this time-honored objective. The astronomical sums commanded by unique art objects are now approximated by the values placed upon rare prints by masters old and new, which, because of their age or their small editions, have inestimable scarcity value.

151 *Andrew Stasik*. State of the Union. *1970.*
 Lithograph, silkscreen, and stencil,
 24 × 31″. Courtesy the artist
152 *Nivisksiak (20th-century Eskimo)*. Man
 Hunting at a Seal Hole in Ice. *Stencil*
 print. Brooklyn Museum, New York
153 *Lucas Samaras*. Book. *1968. Silkscreen on*
 die-cut plywood. Museum of Modern
 Art, New York

152

153

No such factors affect the silkscreen print, which is capable of supplying any conceivable demand by the public if produced with the capacities of a mechanized modern workshop. Yet the large sums paid for multiples signed by "famous brand" names indicate an artificial scarcity created by planned limitation, so that the high cost of mechanization, labor, and overhead in the print shops is not offset by means of mass distribution. Perhaps it is the humble, truly handmade print, designed, produced, and printed in the artist's workshop, that in the end will survive and become the highly priced—and prized—"old master."

For the present, the silkscreen process as an art medium has proved its usefulness beyond a doubt. In some respects it has offered to the twentieth century what the first woodcuts did for the fifteenth—a relatively quick, creative way of disseminating ideas and images across the world.

154 *Miroslav Šutej. Untitled. 1965. Silkscreen, 18 × 15 5/8". Collection Andrew Stasik, New York*

OPPOSITE PAGE:
17 *Josef Albers. No. VII (above) and No. X (below) from the portfolio* Variants. *1967. Silkscreen. Collection Irving J. Finkelstein, Houston, Tex.*

Eduardo Paolozzi. Universal Electronic Vacuum, No. 6863 (7 Pyramide in Form einer Achtelskugel). 1967. Silkscreen, 40 × 27". Editions Alecto, London

Clayton Pond. Chair. 1966. Silkscreen, 1/4 × 6 3/8". Collection the author

Norio Azuma. Image E. 1969. Silkscreen. Courtesy the artist

Kyeung-Ro Yoon. Pantomime. 1969. Photo-silkscreen, 5 7/8 × 6 7/8". Collection the author

19

20

21

22 *Robert Burkert. March Thaw. 1962.*
Silkscreen, with progressive proofs
1, 2, and 3, 20 3/4 × 32".
Courtesy the artist

23 *Steve Poleskie. Big Patchogue Bent.*
1969. Silkscreen, with preliminary
drawing and progressive proofs 1 and 2,
20 × 26". Courtesy the artist

25

24 *Misch Kohn. End Game. 1968.* Chine collé, *etching, and silkscreen, 23 3/4 × 17 3/4". Courtesy the artist*
25 *Helen Bozeat. Untitled. 1970. Photo-silkscreen, 15 × 10 5/8". Courtesy Pratt Institute, Brooklyn, New York*
26 *Roy Lichtenstein. Cathedral 2. 1969. Color lithograph, 32 1/2 × 48 1/2". ⓒ Gemini G.E.L., Los Angeles*
27 *June Wayne. Diktat,* from the series on the genetic code. *1970. Color lithograph, 23 1/2 × 39". Courtesy the artist*

26

27

28 Jasper Johns. Figure 0. *1969. Color lithograph, 38 × 31″.* © *Gemini G.E.L., Los Angeles*

CHAPTER 5

SILKSCREEN

Technique

PLATES 155-161

Making the Screen

Although satisfactory screens can now be purchased ready-made, many artists still prefer to construct their own, which can be built quite inexpensively. The wooden members of the frame must be strong enough to withstand long use and must remain absolutely rigid under considerable pressure, to ensure accuracy of registration. The silk (or other mesh material) must be strong and not inclined to ripple or stretch. Nylon and other synthetic fibers, while usable, tend to be more expensive and more prone to stretch than silk. Even fine metal mesh can be used; it provides an extremely rigid surface for very fine line work but can easily be dented.

The best silk can stand the greatest abuse and may last through many cleanings and several editions, if carefully handled. The closeness or coarseness of the mesh determines to some extent the texture of the print, and must be decided on the merits of each individual artist's intentions. Silk is graded from 6x, coarse, to 20xx, very fine; 12x is a versatile medium grade.

The size of the screen frame and baseboard depends on the maximum paper and image size desired and is limited by the width of silk available (allowing for a comfortable overlap).

The sides of the frame can be constructed from 1-by-2-inch or 1-by-3-inch pieces of smooth, medium-hard wood. These should be cut to the desired length and then staggered the width of the member to allow for interlocking corners. The corners are then securely screwed together; they must be checked against a square-edge to ensure perfect right angles and can be further strengthened with metal braces.

The silk, which should be slightly larger than the maximum dimensions of the frame, is then laid on and centered. The center of one side is then tacked or stapled in two or three places. With the fabric pulled very tight, the opposite side is similarly tacked to the frame. The same procedure is followed with the remaining two sides. Tacking continues from the center toward the corners, alternating sides, with constant pulling on the fabric. When completely tacked down, the fabric should be perfectly smooth and as tight as a drumhead.

At this point the area where silk meets wood may be reinforced with a tape margin. The frame should be turned over, silk side down, and a strip of gummed paper or cloth-backed tape attached to the silk all around the edge of the frame. The tape should be folded to extend part way up the wood to prevent seepage of ink between silk and frame.

A baseboard is then constructed of 1/2-inch-thick plywood. It should extend about 2 inches beyond the frame on each side, with a slightly wider overlap, if necessary, on the hinge side. In order to obtain an absolutely smooth printing surface, the plywood should be covered with a sheet of Masonite, nailed to the baseboard along its four edges. As an alternative to Masonite a sheet of Formica may be glued on.

The screen is attached to its baseboard with two movable-pin hinges to allow easy removal of the screen for cleaning.

Two alignment blocks (to keep the frame from shifting position during printing) can be attached to the baseboard at the right and left of the frame near the front corners; these are essential for proper registration in multicolor printing.

Now the frame, taped margin, and baseboard (unless Formica has been used) should receive several coats of shellac or plastic finish, sanded lightly between coats.

Various types of handles and props may be added to the frame to increase the efficiency of the printing procedure.

The Squeegee

The squeegee consists of a thick but flexible rubber or synthetic blade mounted in a wooden handle; it is used to force ink through the open mesh of the prepared silkscreen onto the paper. A wide variety of blades and handles are available commercially; these may be purchased either separately or already assembled. A process of trial and error will enable the artist to find the proper blade type and handle shape for his particular needs.

The blade must be flexible enough to ensure close contact with the paper and yet stiff enough not to bend excessively or wobble during printing. An unmounted blade may be tested by holding it between thumb and forefinger and trying to double it over. It should resist doubling, even at great pressure, and should always spring back into shape upon release.

The usual type of handle extends the full length of the blade and should be high enough for the fingers to be comfortably extended during printing. The squeegee should be at least an inch longer than the narrow dimension of the maximum image size to be printed. Some shorter squeegees come equipped with a vertical handle at the center of the blade holder; these are used by pushing rather than pulling across the screen.

In assembling a squeegee, the handle is cut to desired length, and the blade is worked into the socket and tapped against a flat surface to drive the blade in. A few nails or screws should be inserted on either side of the handle to hold the blade firmly in place. The handle may then be shellacked. The blade should be kept sharp and nick-free by rubbing on fine sandpaper.

Drying Equipment

A safe, clean method for drying freshly printed sheets must be provided. It may consist of a simple clothesline with clips or pins, or more elaborate fixed or mobile racks. If a line is used, the clothespins or other clips must swing freely and be moved along the line easily. This allows the prints to hang vertically at all times and makes for flexibility of arrangement. Adequate space must be left between prints to guard against touching one another in the passage of air currents. Light, heat, and moisture should be controlled to ensure slow, even drying.

If a rigid wooden frame or rack is constructed (to hang from a wall or be mounted on rollers like a mobile coat rack), the clips should be allowed to swivel freely by means of a nail driven through their central hole or some similar device.

Preparing Paper Stencils

The format should be planned to allow for a generous margin in relation to both the screen surface and the paper size. The image areas (open areas of the stencil) should be small enough to allow the squeegee to pass over them in one stroke without impinging on the tape margin.

Although many types of paper may theoretically be suitable for making stencils, certain characteristics are essential for trouble-free printing. The paper should be very thin, though strong and impermeable. It should cut cleanly with a sharp stencil knife

and not be prone to wrinkling or expansion under changing atmospheric conditions. Some very serviceable papers are lightweight bond paper, artists' "visualizer" paper, and lightweight vellum. Vellum and "visualizer" papers have the added advantage of transparency, which allows stencils to be cut more accurately in sequence.

Usually a separate stencil is cut for each color area of the design. However, when there is ample space between open areas, several forms may be cut into one stencil, each representing a separate color. During printing, secondary paper stencils are placed underneath the master stencil to block out areas which are not to print. These secondary stencils are removed and rearranged as printing progresses from color to color.

The artist may decide to use a working copy in the form of a master drawing or full-color sketch, which will guide the preparation of the stencils. On a piece of heavy white stock the maximum dimensions of the image are marked in strong line; the image is then drawn or transferred to this sheet. If, in the course of stencil-making or printing, the design or printed image deviates markedly from the original drawing, it may be necessary to substitute one of the printed proofs for the original drawing. This print then becomes the working copy, on which the subsequent stencils are based.

Preparing Lacquer-film Stencils
The lacquer-film stencil consists of a layer of lacquer laminated to a backing of transparent paper or Mylar plastic. The transparency is needed so that working copy may be placed underneath to serve as a guide in cutting the design. The image is cut through the lacquer layer only, with a light touch and a very sharp stencil knife. Areas intended to print are stripped away as soon as they are cut. The screen to which the stencil is to be attached should be cleaned with either lacquer thinner or soap and water before the stencil is placed. To ensure perfect adhesion of the film stencil, the screen must be entirely free of soil, sizing, or oily residue.

To attach the film stencil an adhesive fluid and some soft cotton rags are required. The usual procedure is as follows: First, the cut stencil is attached to the underside of the screen (film or lacquer side toward the silk) by means of three or four small pieces of masking tape to hold it temporarily.

Next, a soft, even padding, or "build-up," is placed on a level tabletop. Several sheets of newsprint should be adequate. The screen, with stencil held temporarily by masking tape, is placed face down on this padded surface to keep the stencil in close and firm contact with the screen.

Then two small soft pads are made by folding the cotton rag to a size of about 4 by 4 inches. One of these will be a "wet" pad; the other will be "dry." One is held in each hand.

The "wet" pad is moistened with adhesive fluid and applied briefly to an upper corner of the screen so that it penetrates to a small area of the lacquer film. About 4 by 5 inches should be wetted, then rubbed dry (gently) with the other pad. The adhering proceeds, area by area, with alternate wetting and drying until the entire film has been attached. As adhesion takes place, the softened lacquer moves upward into and between the interstices of the silk, becoming visibly deeper in color in the process. This deepening of color serves as a reliable indication of whether an area has been sufficiently treated. Caution and judgment must be exercised to avoid too much

155 Carol Summers. Fuji. 1971. Color silkscreen, 40 × 30". Courtesy Associated American Artists, New York

or too little moistening. Too many applications to one area will "dissolve" the adhesive, resulting in softened, imprecise edges in the final print.

Upon completion of this process, the screen is allowed to dry for about 10 minutes before the paper or plastic support backing can be stripped off. To remove the backing, a corner is gently lifted with a fingernail and peeled slowly and cautiously away. It should come away clean and intact, with no lacquer clinging to it. Margins beyond the film area are masked or blocked in with glue, and the stencil is ready to print.

To remove a lacquer-film stencil, lacquer thinner or destenciling liquid is used.

Preparing Glue Block-out Stencils

The liquid block-out stencil is the most painterly, autographic, and calligraphic means of stencil making. The nonprinting (negative) areas are blocked, or stopped out, by brushing on the screen a liquid which, when dry, will resist the solvent action of the printing ink. Such stencils have the advantages of ease of application and removal, a wide range of stylistic possibilities, and excellent durability for large editions. Vegetable or animal glues (such as LePage's Liquid Strength Glue), mucilage, and water-soluble gums are ideal for the block-out. White polymer emulsion glues should be avoided, as they are very difficult to remove. Lacquer and commercial silkscreen block-outs are also very useful.

With the liquid the artist paints on the screen (including the margins) a negative of his intended image. By adding or removing glue as the print progresses, he can build upon or cancel the forms created on a basic glue stencil. Some artists tint the block-out glue with tempera to keep a visual record of their manipulations of the stencil in the screen. Gauging the ultimate result, especially when a number of screens are to be overprinted, can become a rather complex matter. Trial and error is the only solution until sufficient experience is gained. Once the uncomfortable feeling of working in negative rather than positive forms is overcome, the glue block-out stencil becomes one of the most sensitive and versatile of stencil techniques.

Textural effects in silkscreen may be achieved by applying glue to a textile or other textured material and pressing it onto the screen surface.

Liquid block-out stencils can sometimes be reused for printing subsequent colors by either adding glue or by subtracting it from certain areas with solvent. This practice is particularly useful when overprintings of several transparent colors are desired.

Preparing Tusche-and-Glue Stencils

A variant of the glue block-out stencil is the tusche-and-glue stencil. In this method the positive image is drawn or painted directly into the silk with a glue resist. Greasy, oil-based resists such as lithographers' crayons, rubbing ink, oil pastels, grease pencils, asphaltum, or liquid tusche are used. A very heavy coverage of grease is required to ensure success.

Once the positive grease image is completed and dry, the screen is propped up horizontally an inch or two above the table surface so that the silk does not touch at any point. A glue mixture of about the consistency of heavy cream is prepared for blocking in the screen. The most popular mixture is 5 parts of LePage's Liquid Strength Glue, 4 parts of water, and a few drops of vinegar or acetic acid. A small

amount of glycerine may be added, if necessary, to increase the flexibility of the dried glue. With a thin, lightweight card (about 3 by 4 inches) a small amount of glue is carried to the inside of the screen and gently carded across the silk to get a thin, even coating. More glue is added in small amounts until the entire screen has been thinly covered. This is allowed to dry while the screen remains horizontal. As soon as the glue is dry (in about 30 minutes), the screen is lifted and examined for pinholes or gaps in the glue. It may be necessary to repeat this glueing-in process, always with a minimum of glue.

After the glue is dry, several layers of newspaper are placed on the work table and wetted liberally with kerosene, turpentine, or benzine. The screen is then placed (silk side down) on this padding of solvent-soaked papers and rubbed down against it from the inside with rags and more of the same solvent. It takes a few minutes for the solvent to work against the grease image from the underside of the silk. Then more solvent is rubbed on with rags from above. This should dissolve the grease image, taking with it any glue sitting on top of the grease. When the grease resist has been removed with the solvent, the screen is dried with rags or newspaper and examined against the light. The areas that were drawn in with grease should be clean and open and ready to print. After printing is completed, the glue stencil can be removed by washing with warm water.

Photographic Stencils

Photographic stencils of light-sensitive gelatin may be purchased in kit form with the chemicals necessary to develop them. Lights, photographic exposure frames, and trays for developing must be added to the ordinary silkscreen equipment if photo techniques are to be used. A fascinating range of effects can be attained by combining photographic positives and negatives with drawn elements. Indeed, almost the whole gamut of traditional silkscreen methods can be used with photographic images by drawing directly on the gelatin film, exposing drawings done on acetate sheets, or adding images directly to the screen after the photo-stencil has been affixed.

Papers and Inks

Although silkscreen prints can be made on any kind of paper, artists generally prefer a fairly heavy, smooth, full-rag paper, because, in addition to ease of printing and

157 Keith Milow. Print A. 1969. Color silkscreen, 20 1/4 × 30 1/4". Museum of Modern Art, New York

158

159

160 *Andrew Stasik.* The Night Game. *1970. Litho–silkscreen–stencil, 30 1/4 × 22 1/4". Courtesy the artist*

161 *Eduardo Paolozzi.* Wittgenstein in New York, *from the portfolio* As Is When, *Editions Alecto, London, 1965. Color silkscreen, 30 × 21 1/8". Courtesy Museum of Modern Art, New York*

160

161

handling, longevity of the finished print is an important factor. A cheaper paper of lighter weight should be on hand for trial proofing. Extra sheets of the paper for an edition should be on hand to allow for the inevitable waste and imperfect proofs; one should add at least ten extras for an edition of fifty.

A wide variety of printing inks, artists' oil colors, and screen-process colors (which come in both mat and glossy types) can be used in silkscreen printing. They will print from opaque to highly transparent, depending on the admixture of transparent base, toner base, and thinning varnish. For an extremely transparent hue, highly concentrated pigments such as tinting colors should be mixed with a relatively high proportion of extender. The addition of toner base and varnish to the thick transparent base should take place before the pigment is introduced. The proportions will vary according to the thinness and flexibility required, but the transparent base should make up at least 50 percent of the mixture.

First the pigment itself should be worked on an ink slab with small amounts of the base mixture added from time to time until the two are thoroughly mixed. This will prevent the formation of lumps of concentrated pigment in the final mixture. Color and tone of the ink may be tested by dabbing or rubbing it on a scrap of the edition paper, but the manageability of the ink can be revealed only in trial proofing. It may be necessary to thicken or thin it slightly by adding more transparent base or thinning varnish.

A generous amount of each color needed should be mixed to ensure a uniform edition. Excess ink may be stored in covered tins for several months.

Printing

For printing, the screen and baseboard should be placed on a table of comfortable height, with easy access to the entire screen surface. The screen itself must be checked before printing to make sure that there are no pinholes in the blocked-out areas or obstructions in the open areas.

If several colors are to be printed, accurate registration can be accomplished by using register tabs. These can be constructed from small strips of heavy paper. The working proof is then placed in position on the baseboard and taped down. Two tabs are fitted against each of two adjacent sides of the proof and securely taped down. The work proof can now be removed and the first piece of proofing paper inserted within the tabs. Tabs of plastic or metal should be used for very large editions or when unusually heavy stock is to be printed.

A generous amount of ink should be poured in a line along the margin of a short end of the screen. Standing at the opposite short end with the screen braced against his body, the artist then pulls the squeegee firmly across the screen. Enough ink for several pulls may be poured at one time, but care should be taken to replenish before the supply on the screen becomes too scant to print evenly across the whole surface.

After the squeegee has been drawn across the screen, excess ink should be deposited in the margin by gently tapping the squeegee once or twice. The screen is now lifted, the first proof removed, and the next sheet eased into place against the tabs. For the second squeegee stroke the artist moves to the opposite end of the screen and draws the excess ink back across the surface.

Trial proofs should be carefully checked for evenness of printing and all necessary alterations made to the stencil before edition printing begins.

When a full run of one color is finished, the screen should be thoroughly cleaned of ink. First the heavy deposit of excess is scooped off with a spatula to be stored or discarded. Then the paper stencil (if used) is removed. The tape border is also stripped off if it has received ink (this border may be cleaned and reused). Newspaper is placed beneath the screen and paint thinner or other solvent is poured over the silk to liquify all traces of ink. The silk is rubbed with a rag, forcing the solvent and ink onto the paper below. Rubbing is continued, with more rags if necessary, until the screen is dry and free of ink. Persistently clogged areas may be scrubbed gently with a small brush. When the screen is clean and dry, the papers are removed and the baseboard dried. The squeegee, of course, should also be thoroughly cleaned with solvent.

Unless the glue stencil is to be saved, it should be washed out by immersing the screen in warm water or by hosing. A brush and soap may be used to expedite the washing. The clean screen should be dried and checked to see that the mesh is completely open.

A special destenciling fluid or lacquer thinner will remove film stencils. It is critically important that all vestiges of ink be removed at the completion of the day's printing. Inks allowed to harden in the mesh of the silk can be removed only by strong solvents or paint removers and much rough scrubbing, which leads to runs and tears and shortens the life of the silk.

CHAPTER 6

NOTES ON SILKSCREEN TECHNIQUES

by Prominent Printmakers

The personal preferences and methods described and illustrated below present only a brief sampling of the possible variations on the silkscreen process as it is utilized by today's printmakers.

The Silkscreen Technique of
NORIO AZUMA

Azuma prefers oil paint, chiefly Shiva or Windsor & Newton, to silkscreen inks. He uses 12- to 15-gauge silk, and for a stopping-out medium, instead of varnish, a mixture of ordinary LePage's glue diluted with 40 percent water, 8 percent white vinegar, and 2 percent glycerine, for a total of 50 percent glue. He finds that this is a very flexible and effective medium, with which he can produce any kind of stroke, fine or broad.

COLORPLATE 20

For texture he uses a mixture of sugar and water applied to the silk. It is easily washed out and leaves a slight pebbly grain, which he finds agreeable for his type of work. For his hard-edged shapes he uses paper stencils, and in order to create a kind of three-dimensional effect his squeegee has two edges, one rounded and one sharp, which builds up a rim of pigment on the edges of certain stenciled shapes.

His largest silkscreens are not printed on paper but on stretched linen canvas. He brushes them first with a coat of white oil paint, which is allowed to dry for several days. He then puts on the first shape, then another, and so on, building up a slight three-dimensional effect, with three or four shapes overlapping.

The editions on paper are usually limited to twenty for the larger prints and up to a hundred for the smaller ones.

ROBERT BURKERT
My Serigraphs

COLORPLATE 22

My ideas come from many sources, primarily from a direct study of nature through sketching trips, color photos and magazine clippings of objects or scenes that intrigue me. This body of material is spread around my studio and slowly assimilated. Over a year may pass before my visual ideas for a new serigraph edition take shape.

Most of my printing is done in the warmer months, because my studio needs a lot of ventilation during the printing and drying. When spring comes, I slow down on the painting that occupies me in the winter, and I make sketches for the four or five prints that I plan for the summer and fall.

I make a study sheet for each print, visualizing it in thumbnail sketches and quick color studies for each of the intended prints. My serigraphs average eight to twelve color runs. I usually print an edition of sixty, with fifteen artist's proofs and an additional fifteen to provide for the inevitable errors. The misprints are destroyed after the edition is completed. This makes a total run of ninety prints. Although I occasionally use others, my favorite paper is Tuscan Cover in Antique White.

Starting with a freshly cleaned silkscreen, usually 12xx in mesh count, I block in with water-diluted LePage's glue the first color run. This is generally a primary color, light and very transparent, with lots of silkscreen transparent base. The first two or three color runs are of transparent primaries, akin to underpainting, in broad abstract patterns. The first three runs, if they are variations on red, yellow, and blue, give me a rich textural surface of colors which will mix optically to give browns, greens, violets, and grays. These runs also tend to block out the large basic forms of

sky, earth, water, grass, and so on. But it is *very* important to me that I can still modify and shift as the print progresses.

In this imaginary landscape I might print the sky with an overtone of semiopaque blue-gray, with lots of white in it. This will cool the sky down and appreciably modify the texture and color of the preceding three runs. The sky shape can be achieved with a cut-paper stencil made from smooth newsprint.

The fifth run might be a linear band of trees on the horizon in the upper middle of the print. This is drawn on a fine screen (16xx) with Maskoid (liquid rubber cement) applied directly to the silk with a carefully blunted ruling pen. When this band is drawn and dry, two coats of water-thinned glue are pulled slowly but firmly over the Maskoid-drawn trees. The first coat should dry before the second glue-up is pulled over it. When both coats are dry, the Maskoid is rubbed out and the tree band printed in a brownish gray. The next color run may be semitransparent triangular white snow shapes in the foreground and perhaps soft yellow-white patches of cloud in the lower sky. The snow will be drawn on the screen with glue block-out and the cloud forms softened with glue applied by cellulose sponges to create a broken, stippled texture. When the glue is dry, I proceed to mix two colors for a "rainbow" type of printing procedure. The yellowish white goes in the upper part of the screen; the bluish, very opaque white goes in the lower part. The colors are squeegeed from left to right to ensure accuracy of position in the edition. I have been using this "rainbow" effect more and more, as it gives me more colors with less work and creates the desired atmosphere.

Next I might draw windswept grass and weed patterns in ocher between the snow patches. These are also drawn with Maskoid, which I find the best medium for linear detail. Some textures are created by rubbing with litho crayon or spattering Maskoid with a toothbrush. Water-thinned glue is pulled over the screen, and when the glue dries, the Maskoid and crayon are washed out with turpentine or mineral spirits. If sharper detail is needed, the glue resist can be touched up with glue and a very fine brush over a light-table.

The sixth color might be printed in a silkscreen enamel paint to give a bit of relief to the lines. As enamel tends to clog the detail in printing, the screen may have to be washed out several times.

If the print needs some verticals and diagonals, perhaps some scrubby, stunted tree forms to bridge the horizontals of tree bands and sky, Maskoid is used on a newly cleaned screen. (I work with only about four or five screens.) After gluing and washing out, as before, printing is done with a "rainbow" of dark brown enamel at the base of the trees to olive-green enamel at the top.

For the last run a semigloss mixture of transparent base and multiprint varnish (half and half), with just a tint of violet color, is spread over the entire print. This gives a cool atmosphere of evening and also a silky sheen over the print when dry, which finishes it and protects the surface. The completion of this hypothetical serigraph would require eight printings with ten colors.

For the self-portrait, *39 at '70,* in the unusual technique of silkscreen drawing, only *one* screen was used. The similarity to a pencil or chalk drawing comes from the use of pencils directly on the screen. The method is as follows:

First the margins of the screen are glued up to the desired size of the final print. The frame is then locked in register and a piece of paper placed in proper position beneath it.

162 Robert Burkert. 39 at '70. 1970.
Silkscreen (pencil technique), 24 1/4 × 21".
Courtesy the artist

PLATE 162

Soft (ebony) pencils, graphite sticks, powdered graphite, and colored pencils can be used to draw the image on the screen; a lot of the "dust" is left on the screen mesh and openings. Erasers may be used to make corrections and rub in tones, with care to keep the dust from being knocked off the screen.

Glue block-out is used to draw in highlights, as in a chiaroscuro drawing.

A very pale transparent base, either clear or with a dab of color, is pulled over the drawing. A maximum of pressure is required, and it is necessary to go over the drawing with the squeegee several times. Each print pulled gets successively lighter, and one must pull the squeegee over the screen repeatedly to get a strong image. The greatest number of prints obtainable is probably five to eight.

The principle of the method seems to be that the transparent paint lubricates the graphite, dissolves it somewhat, and lets it through the mesh to the paper. The base also locks the pencil marks into the paper so that they cannot be rubbed or smeared.

STEVE POLESKIE
My Silkscreen Methods

I learned the technique of silkscreen printing from a pamphlet put out by one of the paint companies to advertise its product. My first silkscreen frame was second-hand, given to me by a friend who worked in a stained-glass studio. The year was 1959, and I was working in the basement of my parents' home in Pennsylvania.

COLORPLATE 23

Technically, nothing outstanding distinguishes my work. All my current prints are done in a straightforward way with lacquer film, a technique found in any basic textbook on silkscreen printing. I begin with an exact-size line drawing and work out the colors as I go along. In general I do not print a complete proof before I begin, but prefer to work out changes as the print is being completed. Since I usually start with a rather clear image of the print in my head, this method prevents me from losing interest in it as the work proceeds. I usually work with assistants who handle most of the details of the printing.

For several years I worked as a printer, and founded and ran my own silkscreen shop, the Chiron Press in New York City. From 1963 to 1968 we printed the work of many of the prominent artists of the time. During my collaboration with these artists I learned a great deal from them, as I hope they, in turn, learned something from me.

Most of the artists knew little or nothing about silkscreen printing, so that it was necessary for me to give them a brief introductory course before we could begin. Some became interested in the technique and attempted to learn the steps necessary to prepare their own stencils. A few, however, had no interest in anything but the finished product and came around only when it was time to sign the prints. For these artists I did what tradition normally would have demanded of them. I prepared the stencils and mixed the colors, but, contrary to tradition, was not above changing a color or a line if I thought it would improve the print. No one ever complained.

I have never met a printer who wanted only to be a printer, and I was no exception. The ego of an artistic individual is too strong to endure for long the self-negation demanded by the printing of images created by others. I bore the situation for several years, attempting to work out a parallel career as a creative artist. My reputation as a printer, however, seemed to have spread at such a rate as to overshadow all my efforts to build an audience for my own images. This, plus my distaste for the

economic end of the business, caused me to sell the press and take a job teaching at Cornell University.

I intend to develop in my own work both an awareness of the past and an understanding of the present, to comprehend the spontaneity of the moment and the timelessness of the craft. I have found the technique of silkscreen ideally suited to this endeavor.

I am interested in the world around me. For a time, being unable to afford models, I painted my own face and figures from photographs. The figures moved in a never-never land. I lived in the city and thus could not see the land, but it was there—in the advertisements, behind the cars, the soda pop, the cigarettes. As I had stripped the clothes from the figures to create nudes, I stripped away the embellishments of the land to make it land again, free from the desecration of mankind.

In the city I painted the landscape as a blind man paints a scene remembered or one described by someone who has seen it. When I moved to the country, I was confronted by a whole new experience. Now I was *in* the landscape; it surrounded me—miles and miles of it. I tried to finish a few of the pictures I had begun in the city and found them lacking. The colors were wrong, artificial; they were acid and smelled of city air.

My object now is not to re-create the picture as I have already perceived it, but to startle myself, to destroy the image in translation, to cause some mutation to occur during the picture's birth, so that when I perceive it in reality, it is an object strange and foreign to me—fresh, baffling, and exciting.

MISCH KOHN
A Silkscreen Variation on *Chine Collé*

A variation on the *chine collé* technique was employed in my sugar-lift aquatint *End Game*. After the etching was completed, I pulled a proof on wet paper and allowed it to dry. It shrank about 3/8 inch in length.

COLORPLATE 24

I then placed the proof under a silkscreen and traced the areas for the orange background that I wished to print on oatmeal-colored Japanese paper. A white was printed as a second color on the orange.

The dried silkscreen prints were then trimmed to the edge of the image area and dampened between blotters in a damp-book wrapped in plastic.

The backing sheet for the print, a heavyweight Rives paper, was also dampened and placed in the damp-book at the same time. A few drops of formaldehyde in distilled water (as much as a thimbleful per gallon of distilled water) allows the paper to stand as much as two weeks' dampening without danger of mold.

I then used the etched proof to design the additional colors, the gold leaf, red, blue, and green papers. Using a tracing sheet as a template, I scored through it with an etching point onto the various papers. These I placed in the damp-book shortly before printing.

The etching was inked in intaglio, and the surface was cleaned with paper towels over a smooth 3-inch-by-3-foot block.

Next a white library paste was thinned with water to the consistency of thick coffee cream. The trimmed screen print and the colored papers were turned upside down on damp blotters and washed lightly with the thinned paste, applied with a

1 1/2-inch-wide soft paintbrush. Then each piece of colored paper was laid in position on the plate with the paste side up. (It is necessary to lay those which are to be on top first and so on in succession.) Finally the trimmed silkscreen print was laid on the plate and stretched to reach all the corners. The Rives backing sheet with a wide border was laid on the plate in position, the blanket placed upon it, and the print pulled.

JAMES LANIER
The Preparation of Photographic Silkscreens
The screen is prepared as for any other serigraphic method. Cleanliness is essential. Even if new, the screen should be thoroughly scrubbed with some cleanser such as Ajax and rinsed carefully. Some screen materials are not suitable for film emulsion, and one should check this point with the manufacturer before using them.

The art work may be composed of film positives or other designs prepared on a transparent base.

The screen is sensitized with a prepared liquid emulsion, or it is adhered to a film emulsion cut to size, with an allowance for overlap beyond any printing area. The liquid emulsion should be applied according to the manufacturer's instruction. Usually the workroom should be semidark; the mixture is poured onto one edge of the screen and squeegeed across to form a thin, even coating. This is wiped and then fanned dry.

The screen or film is exposed to light according to the instructions of the manufacturer. It is my experience that only an arc light gives excellent results, but I have also obtained satisfactory results with exposure to the sun, to photo flash bulbs, or to an ultraviolet sunlamp. Timing of the exposure depends upon the intensity of the light and the type of emulsion used.

Afterward, the washing out or development of the screen or film should proceed as recommended by the manufacturer. When film is used, two steps are required in developing the film. First, a special developer is used, and then the film is washed out in 115-degree water. The temperature is critical in this procedure. Then the film is fixed in cold, fresh water.

While still wet, the developed film is placed on several sheets of newsprint, face up on a flat surface, and the screen is lowered in exact position on the film. Several more sheets of newsprint are laid on top of the screen and pressed firmly with the side of the hand, working from the center to the edges, so that the film is firmly adhered to the screen. The newsprint both over and under the screen should be changed as frequently as necessary until dry.

Four to six hours drying time is required for the film method. When dry, the acetate backing of the film is peeled off. The emulsion is then cleaned with a soft cloth and benzine applied without pressure.

The screen is now ready for any blocking out that may be necessary.

Selected Bibliography

General Works: History

Adhémar, Jean. *Graphic Art of the 18th Century*. McGraw-Hill, Inc., New York, 1964

Andresen, Andreas. *Der Deutsche Peintre-Graveur,* 5 vols. Leipzig, 1864–78; reprint, Collectors Editions, New York, n.d.

Ars Multiplicata, catalogue, Wallraf-Richartz Museums, Cologne, 1968

Bartsch, Adam von. *Le Peintre-graveur* (15th–17th centuries), 21 vols. Verlagsdruckerei Würzburg G.b. H., Würzburg, 1920

Baskett, Mary Welsh. *American Graphic Workshops: 1968,* catalogue, Cincinnati Art Museum, Cincinnati, Ohio, 1968

Beall, Karen F., et al. *American Prints in the Library of Congress.* Johns Hopkins Press, Baltimore, Md., 1970

Bersier, Jean-Eugène. *La Gravure: Les Procédés, L'Histoire.* Berger Levrault, Paris, 1963

Bloch, Georges. *Pablo Picasso: Catalogue of the Printed Graphic Work 1904–1967.* Editions Kornfeld and Klipstein, Berne, 1968

Bockhoff, Hermann, and Fritz Winger. *Das Grosse Buch Der Graphik.* Georg Westermann Verlag, Braunschweig, 1968

Bolliger, Hans. *Picasso for Vollard,* trans. Norbert Guterman. Harry N. Abrams, Inc., New York, 1956

Breitenbach, Edgar, and Margaret Cogswell. *The American Poster.* The American Federation of Arts and October House, Inc., New York, 1968

Brückner, Wolfgang. *Imagerie Populaire Allemande.* Electa, Milan, 1969

Buchheim, Lothar-Günther. *The Graphic Art of German Expressionism.* Universe Books, New York, 1960

———. *Max Beckmann.* Buchheim Verlag, Feldafing, 1959

Carrington, Fitz Roy, and Campbell Dodgson, eds. *The Print Collector's Quarterly,* 30 vols. New York and London, 1911–1951

Cleaver, James. *A History of Graphic Art.* Philosophical Library, New York, 1963

Delteil, Loys. *Manuel de l'amateur d'estampes des XIXᵉ et XXᵉ siècles (1801–1924),* 4 vols. Dorbon-Aîné, Paris, 1925

———. *Le Peintre-graveur illustré (XIXᵉ et XXᵉ siècles),* 32 vols. Paris, 1906–30; reprint, Collectors Editions and Da Capo Press, New York, 1968

Dumont, Jean-Marie. *Les Maîtres Graveurs Populaires 1800–1850.* L'Imagerie Pellerin, Épinal, 1965

Eichenberg, Fritz, ed. *Artist's Proof Annual.* Pratt Institute, Barre Publishers, and New York Graphic Society, New York, 1961–present; Collector's Edition, reprint of first eight issues, 1972

Fischer, Otto. *Geschichte der Deutschen Zeichnung und Graphik.* F. Bruckmann Verlag, Munich, 1957

Foster, Joseph K. *Posters of Picasso.* Grosset and Dunlap, New York, 1964

Gaehde, Christa M., and Carl Zigrosser. *A Guide to the Collecting and Care of Original Prints.* Crown Publishers, Inc., New York, 1965

Getlein, Frank and Dorothy. *The Bite of the Print.* Bramhall House, New York, 1963

Hargrave, Catherine Perry. *A History of Playing Cards.* Dover Publications, New York, 1966

Harris, Jean. *Édouard Manet, Graphic Works: A Definitive Catalogue Raisonné.* Collectors Editions, New York, 1970

Hayter, Stanley William. *About Prints.* Oxford University Press, London, 1962

Hofman, Werner. *Georges Braque: His Graphic Work.* Harry N. Abrams, Inc., New York, n.d. [1961]

Hogben, Lancelot. *From Cave Painting to Comic Strip.* Chanticleer Press, New York, 1949

Hunter, Sam. *Joan Miró: His Graphic Work.* Harry N. Abrams, Inc., New York, n.d. [1958]

Ivins, William M., Jr. *How Prints Look.* Metropolitan Museum of Art, New York, 1943

———. *Notes on Prints.* Metropolitan Museum of Art, New York, 1930

———. *Prints and Visual Communication.* New York, 1953; reprint, Da Capo Press, New York, 1969

Knappe, Karl Adolf. *Dürer: The Complete Engravings, Etchings, and Woodcuts.* Harry N. Abrams, Inc., New York, 1965

Koschatzky, Walter, and Alice Strobl. *Die Albertina in Wien.* Residenz Verlag, Salzburg, 1970

Kristeller, Paul. *Kupferstich und Holzschnitt in Vier Jahrhunderten.* Bruno Cassirer, Berlin, 1922

Leonard Baskin: The Graphic Work, 1950–1970, catalogue, FAR Gallery, New York, 1970

Leonhard, Kurt. *Picasso: Recent Etchings, Lithographs and Linoleum Cuts.* Harry N. Abrams, Inc., New York, n.d.

Ljubljana Biennale, catalogues, a series illustrating the Yugoslavian exhibitions, under the direction of Zoran Kržišnik, held since 1953

Longstreet, Stephen. *A Treasury of the World's Great Prints: From Dürer to Chagall.* Simon and Schuster, New York, 1961

Mayor, A. Hyatt. *Prints & People.* Metropolitan Museum of Art, New York, 1971

McNulty, Kneeland. *The Collected Prints of Ben Shahn,* catalogue, Philadelphia Museum of Art, 1967

Meyer, Franz. *Marc Chagall: His Graphic Work.* Harry N. Abrams, Inc., New York, 1957

Mongan, Elizabeth, and Carl O. Schniewind. *The First Century of Printmaking: 1400–1500,* catalogue, Art Institute of Chicago, 1941

Orozco, Clemente. *Catalogo Completo de la Obra Grafica de Orozco,* ed. Luigi Marrozzini, Instituto de Cultura Puertorriqueña, San Juan, Puerto Rico, 1970

Panofsky, Erwin. *Albrecht Dürer,* 2 vols. Princeton University Press, Princeton, N.J., 1948

Passeron, Roger. *French Prints of the 20th Century.* Praeger Publishers, Inc., New York, 1970

Picasso: Sixty Years of Graphic Work, catalogue, Los Angeles County Museum of Art. New York Graphic Society, Greenwich, Conn., 1966

Print Council of America. *What Is an Original Print?,* pamphlet, P.C. of A., Inc., 1961

Richards, Maurice, ed. *Posters of Protest and Revolution.* Walker and Co., New York, 1970

Roger-Marx, Claude. *Graphic Art of the 19th Century.* McGraw-Hill, Inc., New York, 1962

———. *La Gravure originale en France de Manet à nos jours.* Hyperion Press, Paris, 1939

Sachs, Paul J. *Modern Prints and Drawings.* Alfred A. Knopf, Inc., New York, 1954

Schiefler, Gustav. *Die Graphik Ernst Ludwig Kirchner, 1917–1927,* 2 vols. Euphorion-Verlag, Berlin, 1929, 1931

Schmidt, Werner. *Russische Graphik des XIX und XX Jahrhunderts.* Seeman, Leipzig, 1967

Shadwell, Wendy. *American Printmaking: The First 150 Years,* catalogue, Museum of Graphic Art, New York, 1969

Shikes, Ralph E. *The Indignant Eye.* Beacon Press, New York, 1969

Sotriffer, Kristian. *Printmaking: History and Technique.* McGraw-Hill, Inc., New York, 1968

Stubbe, Wolf. *Graphic Arts in the 20th Century.* Frederick A. Praeger, New York, 1963

Timm, Werner. *The Graphic Art of Edvard Munch,* trans. Ruth Michaelis-Jena. New York Graphic Society, Greenwich, Conn., 1969

Wechsler, Herman J. *Great Prints and Printmakers.* Harry N. Abrams, Inc., New York, 1967

Werner, Alfred. *The Graphic Works of Odilon Redon.* Dover Publications, Inc., New York, 1969

Wingler, Hans M., ed. *Graphic Work from the Bauhaus,* trans. Gerald Onn. New York Graphic Society, Greenwich, Conn., 1969

Zigrosser, Carl. *The Book of Fine Prints,* rev. ed., Crown Publishers, Inc., 1956

———. *Kaethe Kollwitz.* H. Bittner and Co., New York, 1946

———, ed. *Prints: Thirteen Essays.* Holt, Rinehart and Winston, Inc., New York, 1962

General Works: Technique

Andrews, Michael F. *Creative Printmaking.* Prentice-Hall, Inc., Englewood Cliffs, N.J., 1964

Brunner, Felix. *A Handbook of Graphic Reproductive Processes.* Alec Tiranti, Ltd., London, 1962

Heller, Jules. *Printmaking Today: A Studio Handbook,* 2d ed. Holt, Rinehart and Winston, Inc., New York, 1972

Peterdi, Gabor. *Printmaking.* Macmillan Co., New York, 1959

Ross, John, and Clare Romano. *The Complete Printmaker.* Macmillan Co., New York, 1972

Lithography

Adhémar, Jean. *Toulouse-Lautrec: His Complete Lithographs and Drypoints.* Harry N. Abrams, Inc., New York, 1965

Antreasian, Garo Z., and Clinton Adams. *The Tamarind Book of Lithography: Art & Techniques.* Harry N. Abrams, Inc., New York, 1971

Bild vom Stein, catalogue, State Collection of Graphic Art, Munich. Prestel Verlag, Munich, 1961

Davis, Burke, and Ray King. *The World of Currier and Ives.* Random House, New York, 1968

Dehn, Adolf, and Lawrence Barrett. *How to Draw and Print Lithographs.* Tudor Publishing Co., New York, 1950

Joyant, Maurice. *Henri de Toulouse-Lautrec 1864–1901,* 2 vols. H. Floury, Paris, 1926–27

Julien, Edouard. *Les Affiches de Toulouse-Lautrec.* Editions du Livre, Monte Carlo, 1950

Knigin, Michael, and Murray Zimiles. *The Technique of Fine Art Lithography.* Van Nostrand Reinhold Co., New York, 1970

Lang, Léon. *La Lithographie en France: Des origines au début du romantisme.* Mulhouse, 1946

Larkin, Oliver W. *Daumier: Man of His Time.* Beacon Press, Boston, 1968

Lejeune, Robert. *Honoré Daumier.* Clairfontaine, Lausanne, 1953

Man, Felix. *150 Years of Artists' Lithographs: 1803–1953.* William Heinemann, Ltd., London, 1953

Mourlot, Fernand. *Braque Lithographe*. Editions du Livre, Monte Carlo, 1963

————. *Chagall Lithographe*. Editions du Livre, Monte Carlo, 1960

Peters, Harry T. *Currier and Ives: Printmakers to the American People*. Doubleday & Co., Garden City, N.Y., 1942

Roger-Marx, Claude. *Bonnard Lithographs*. Editions du Livre, Monte Carlo, 1950

————. *L'Oeuvre gravé de Vuillard*. Editions du Livre, Monte Carlo, 1948

————, and Jean Vallery-Radot. *Daumier, le peintre-graveur,* catalogue, Bibliothèque Nationale, Paris, 1958

Sauret, André. *Picasso Lithographe*. Editions du Livre, Monte Carlo, 1960

Senefelder, Alois. *A Complete Course of Lithography*. London, 1819; reprint, Da Capo Press, New York, 1968

Twyman, Michael. "The Lithographic Hand Press 1796–1850," *Journal of the Printing Historical Society,* No. 3, 1967, pp. 3–50

Weaver, Peter. *The Technique of Lithography*. Reinhold Publishing Corp., New York, 1964

Weber, Wilhelm. *A History of Lithography*. McGraw-Hill, Inc., New York, 1966

Silkscreen

Auvil, Kenneth W. *Serigraphy: Silk Screen Techniques for the Artist*. Prentice-Hall, Inc., Englewood Cliffs, N.J., 1965

Biegeleisen, J.I. *Screen Printing: A Contemporary Guide*. Watson-Guptill Publications, Inc., New York, 1971

Carr, Frances. *A Guide to Screen Process Printing*. Studio Vista Books, London, 1961

Chieffo, Clifford T. *Silk Screen as a Fine Art: A Handbook of Contemporary Silk Screen Printing*. Reinhold Publishing Corp., New York, 1967

Fossett, Robert O. *Techniques in Photography for the Silk Screen Printer*. The Signs of the Times Publishing Co., Cincinnati, 1959

Kinsey, Anthony. *Introducing Screen Printing*. Watson-Guptill Publications, Inc., New York, 1968

Kosloff, Albert, *Photographic Screen Process Printing*. The Signs of the Times Publishing Co., Cincinnati, 1968

Shokler, Harry. *Artist's Manual for Silk Screen Print Making*. Tudor Publishing Co., New York, 1960

Index